BRADFORD

THROUGH TIME

Mark Davis

AMBERLEY PUBLISHING

Acknowledgements

Particular thanks must go to those grand old Victorian historians, William Cudworth, Thomas Thornton Empsall and William Scruton, the founders of the Bradford Historical and Antiquarian Society. Their passion for recording Bradford's Victorian history serves today as unique reference material.

I would also like to acknowledge and extend my heartfelt gratitude to the following persons who have made the completion of this book possible: Susan Caton, Bradford Library, local studies department; Tony Earnshaw, writer and broadcaster; Steven Wood, Haworth historian; Roy Lowther, Bradford historian; Reuben Davison, Author; John Tempest; B. Mcabe; West Yorkshire Archives Service, Bradford; *Bradford Telegraph & Argus*.

Dedicated to the memory of my beloved Grandfather Frank Davis

First published 2011

Amberley Publishing
The Hill, Stroud
Gloucestershire, GL5 4EP

www.amberley-books.com

Copyright © Mark Davis, 2011

The right of Mark Davis to be identified as the Author of this work has been asserted in accordance with the Copyrights, Designs and Patents Act 1988.

ISBN 978 1 4456 0330 8

British Library Cataloguing in Publication Data.
A catalogue record for this book is available from the British Library.

Typeset in 9.5pt on 12pt Celeste.
Typesetting by Amberley Publishing.
Printed in the UK.

Introduction

Bradford's rise to fame was almost unique. From being a comparatively small rural market town at the turn of the nineteenth century she grew to be the metropolis of the worsted industry, enjoying a prosperity scarcely equalled by any other conurbation in Great Britain.

Her name is derived from the Old English phrase meaning 'broad ford' by which route ancient travellers would cross the beck at the foot of Church Bank, below what is now the cathedral. Here a primitive settlement developed and the beck was to remain at the heart of the town's growth.

After the Norman Conquest, Bradford became part of the *honour of Pontefract* given to Ilbert De Lacy for his loyalty and service at the Battle of Hastings. A Saxon rebellion at York, where William the Conqueror's defenders were put to death, resulted in the king's men laying waste to Bradford. Thus when the Domesday survey was carried out in 1086 the town was worth virtually nothing, although during the reign of Edward the Confessor the manor was valued at £4, a not-inconsiderable sum in medieval times. The manor was lost to the De Lacy family following the death of Henry, Earl of Lincoln in 1310, but not before Edmund De Lacy had obtained from the Crown a grant of market rights in 1215.

Bradford in medieval times was inhabited from the High Street (Barkerend) by the cathedral, into Kirkgate, Westgate and Ivegate before joining Horton via Tyrrel Street. During the fourteenth century, a ravenous wild boar was at large in the area of Cliff Wood, the legend of which forms part of the city's coat of arms to this day. Another feature of the arms, the three horns, relates to the medieval custom of horn blowing.

By the turn of the sixteenth century the population was in the main occupied with the peaceful pursuit of agriculture although the weaving of woollen fabrics was of increasing important. Towards the end of the Elizabethan era, commerce and the growth of industry were having a positive effect on the standard of living throughout the parish but troubled times were close on the horizon.

When civil war broke out in 1641, Bradford was a parliamentary stronghold. The town was twice beseiged by the Royalists. The first seige, in December 1642, was unsuccessful. The Royalists returned in June 1643, headed by the Earl of Newcastle. Cannon were aimed at the cathedral, its steeple defended by woolsacks. Newcastle ordered the town to be put under the sword before retiring for the night at Bolling Hall. It is said that during the night a ghostly apparition visited him in his chamber imploring him to "pity poor Bradford". Apparently Newcastle was sufficiently moved by this visitation and allowed the townsfolk to go free.

By 1807 Bradford, by now a firmly established market town, was described as "bonny ... with a pleasing aspect". At this time the

population stood at around 7,000. By 1821 this had more than doubled, and by 1834 it stood at 40,000. As a result the town was fast becoming a stinking slum littered with the human wreckage of this newly industrialised society. The introduction of steam power into the textile industry had provoked mass migration to the area. Former agricultural workers gathered their pitiful belongings on their backs; accompanied by their wives and children they trudged many a long mile in search of the promised wealth of the burgeoning industrial town. Irish peasants crossed the sea in droves at half-a-crown a head. In 1835, the Poor Law unions rounded up thousands of impoverished agricultural labourers in the south of England; they were packed into barges and wagons and transported up to the industrial north for absorption.

By the 1840s it was clear that Bradford's municipal development did not compare with its industrial growth. There was little order in the streets, and chimneys appeared everywhere, creating a web of smoke that hung over the landscape like a permanent cloud. Something had to be done. Just one year after the first train steamed into the town in 1846, the young Queen Victoria granted Bradford the Charter of Incorporation. By 1850 the newly formed Corporation had passed an act for better paving, lighting, drainage and street improvements. This was just the beginning.

The period between 1847 and 1897 when Victoria granted Bradford her 'City' status was one of phenomenal growth. From a town with prospects she became the worsted capital of the world, effectively creating the rules and setting the pace. Men of vision like Samuel Cunliffe Lister and Titus Salt showed the world what Bradford was capable of and the world sat up and took notice. Fabulous structures were erected – in particular, during the period between 1867, when the Wool Exchange opened its doors to the great industrialists, and 1873 when the Town Hall commenced its civic duties. There is no doubt that by 1897 Bradford was a mighty city to be reckoned with.

Bradford today is still evolving. Although no longer the centre of excellence for the worsted cloth industry many of its great Victorian buildings remain, some retain their original form and usage while others have undergone conversion to meet the demands of contemporary life.

Join me and take a journey through time in streets of Bradford, as we investigate the changes that have shaped and continue to shape our still great city.

Mark Davis
Haworth,
August 2011

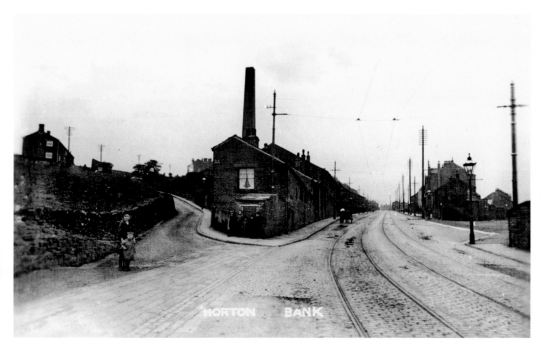

Great Horton Road

Horton Bank, *c.* 1900. Growing up in Bradford as a teenager, like many lads of my age, I had a paper round. It was up Horton Bank and Old Road (to the left) that I would, in all weathers, endeavour to steer my Raleigh Scorpio, laden with a heavy bag of papers. As time went on I did it pedalling – a real achievement for a thirteen-year-old, I can tell you! It is here that we begin our journey through time.

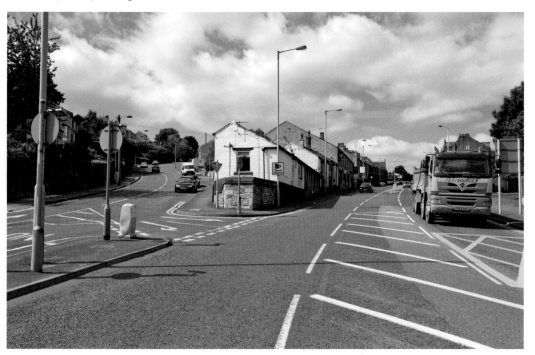

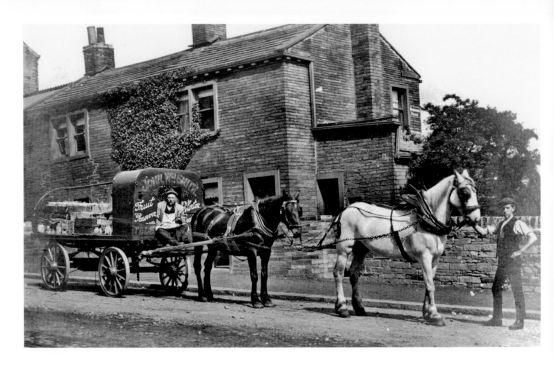

Horton Bank, *c.* 1900

Horton Bank was later to become an extension of Great Horton Road. Here we have a closer view of the bank, as seen in the previous image, but looking to the right. Informed guesswork tells me that it is in fact John William Smith, fruit preserver, himself posing proudly on his cart. I do this with some confidence, knowing that John lived on the bank – more than likely in the house pictured behind him.

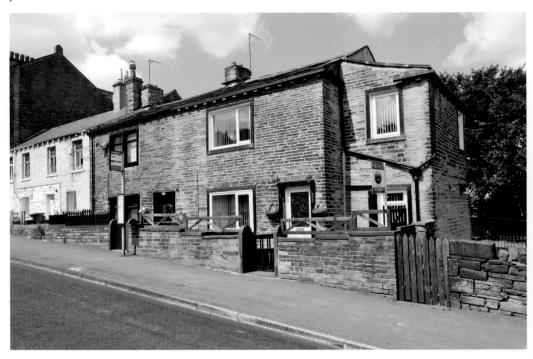

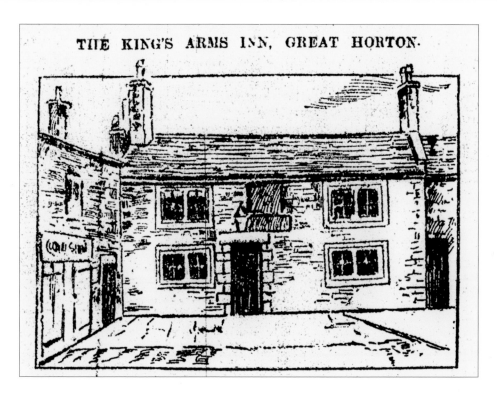

THE KING'S ARMS INN, GREAT HORTON.

The King's Arms, Great Horton, *c.* 1898

Moving down from Horton Bank, we find ourselves in 'Great Horton' proper. The King's Arms was built by Gilbert Brooksbank in 1739 and must rank as one of the oldest public houses in Bradford that is still in its original form. The house was the scene of many stirring gatherings, including the 1807 great county elections when William Wilberforce, Lord Milton and Henry Lascelles contested Yorkshire. The King's Arms was the posting house when mail and stage coaches passed through Horton on their way to Halifax, Manchester and Liverpool.

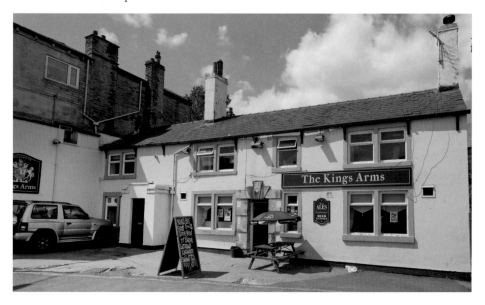

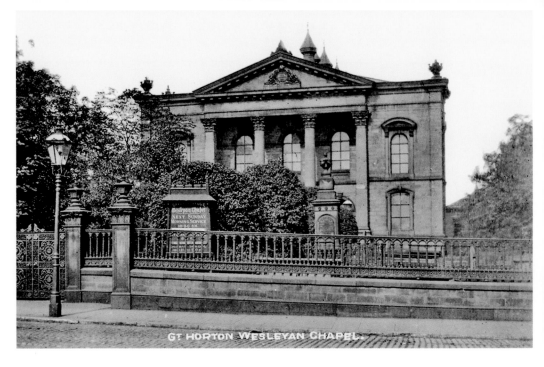

Great Horton Wesleyan Chapel, *c.* **1907**

This lovely old chapel was built in 1814 on the footprint of the old school, which had become far too small. The new, spacious chapel was designed to hold around 500 persons and formally opened on Easter Tuesday, 1815. Much later, in 1862 it was renovated and to this day holds services at 10.30am every Sunday. The motto on the sign outside proclaims '1814 to the present day and beyond'.

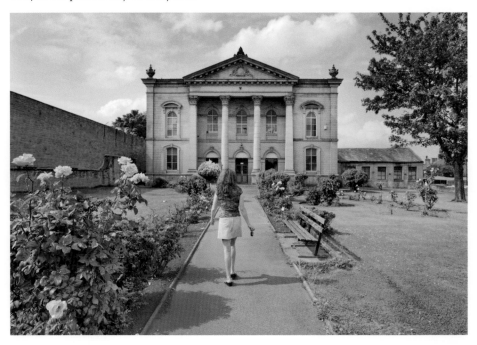

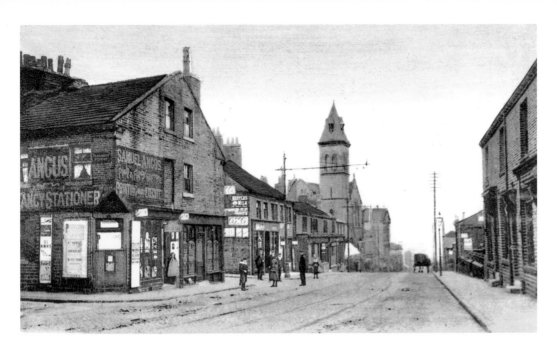

High Street, Great Horton, *c.* 1905

It was in this very area that my wonderful grandmother was brought up, living in a back-to-back cottage on Vine Street just below the Congregational Church. As a child she would walk down Arctic Parade in all weathers on her way to work at Cannon Mills, close by. Today the church has become home to the Ali Baba Carpet emporium. We also see Samuel Angus the stationer's, now long gone, having been demolished making way for modern housing.

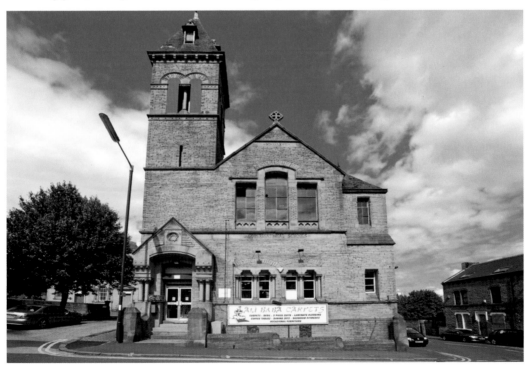

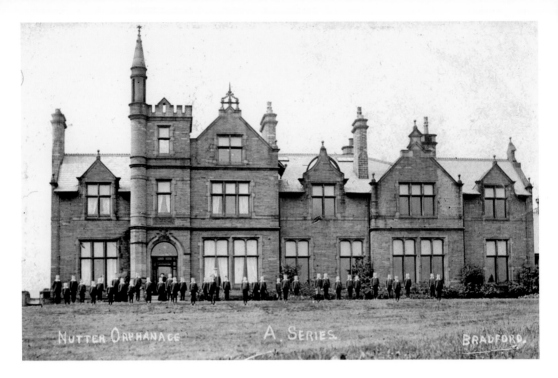

Nutter's Orphanage, Horton, *c*. 1905

A wonderful old, sepia image showing the boys standing to attention, with the master slightly behind. The orphanage opened thanks to Joseph Nutter. A man born into considerable disadvantage himself, on his death he left the sum of £10,000, in order to save young boys from the life he had led in his early years. Today the former institution is empty, awaiting new owners. However, the Roll of Honour remains in the main corridor.

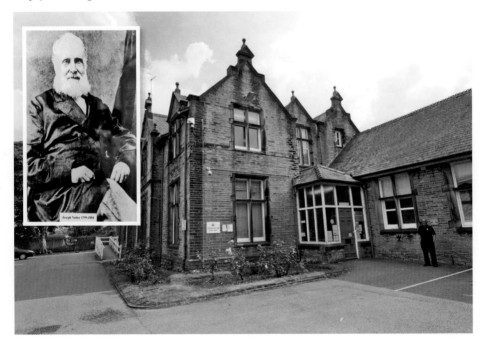

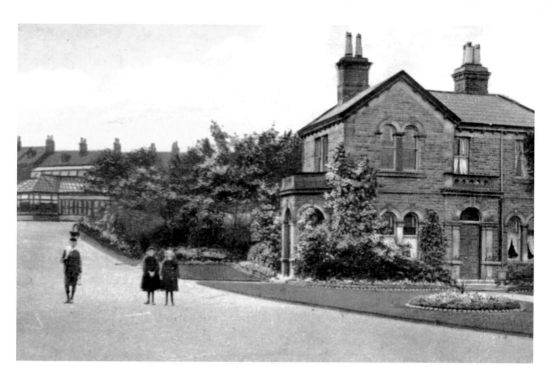

Horton Park Lodge, *c.* 1904

'Dear Albert, if ever you should come to Bradford I will take you to see this pretty park, it is very near to where I live. You will be at school in a week while I am writing this. It's the best time children have, their school days. Love to all, Auntie Mabel.' How right Auntie was! Horton Park to this day remains a very pretty park.

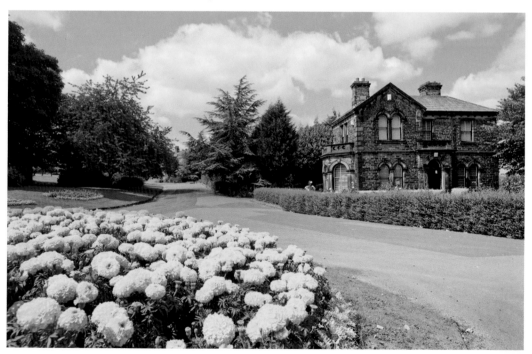

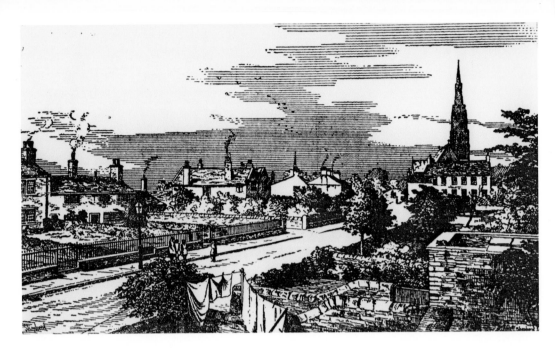

Horton Green, *c.* 1890

Beautifully placed in an elevated position, during Bradford's industrial boom the green was the place to be, refreshing winds ensuring that it was an almost smokeless zone. It is of no wonder that Horton Old Hall was a desirable residence for the wealthy. Many gardens and orchards made the area very attractive and this is equally true today. Just yards away from busy thoroughfares, this little piece of old Bradford remains seemingly untouched by time.

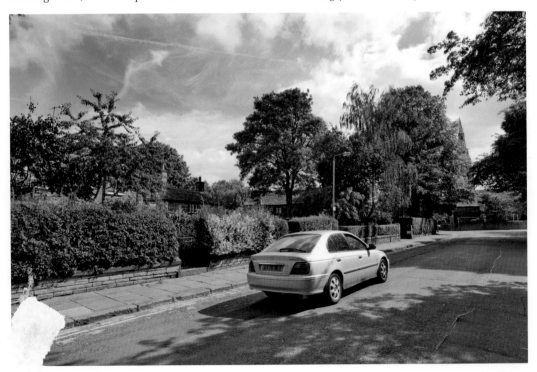

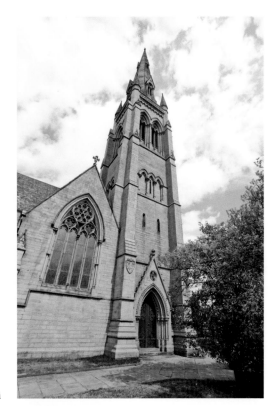

All Saints', Horton Green, 2010
In 1890 the spire of All Saints' was believed to be one of the finest pieces of Gothic architecture in this part of the country. At 201 feet, it was used as an observatory by the Victorian mathematician and astronomer, Abraham Sharp. Erected in 1863, in the hope that it could become Bradford's Cathedral, the church has stood the test of time. Extensive repair work was recently carried out on the spire.

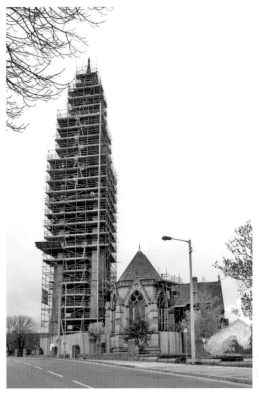

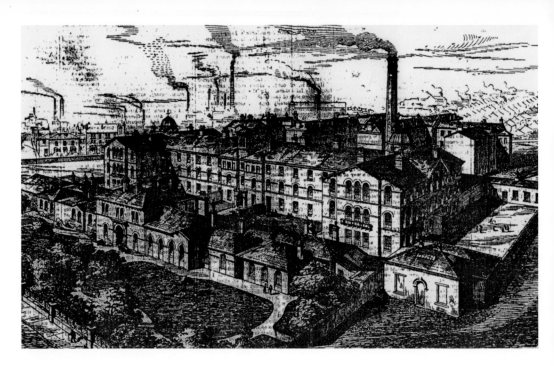

Bradford Union Workhouse, 1887
It's hard to imagine the present St Luke's hospital, Little Horton, was once the Union workhouse referred to as 'The Bastille' by the pauper population of Victorian Bradford. It was the place where the desperate sought poor relief. Attached to the workhouse was the Imbecile Ward, part-asylum, part-workhouse. It was from here that many people were sent to the County Lunatic Asylum.

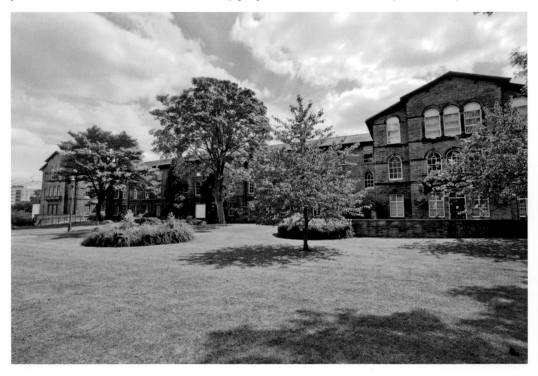

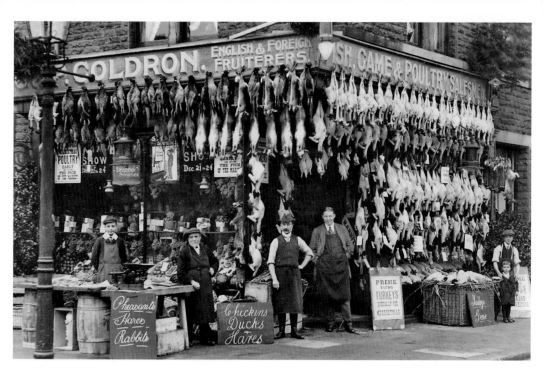

Coldron's, Horton Grange Road, 1912

All ready for Christmas, the staff of Coldron's pose outside their premises, along with the hares, pheasants, ducks, geese and plump turkeys that adorn the shop front. The premises are now a vegetarian curry house. The postcard is dated 24 December 1912, and reads: 'We are very busy, this photo was taken on Saturday. They have been very busy, 2am this morning when they finished. Wishing you a Happy Christmas, love from all, Mary.'

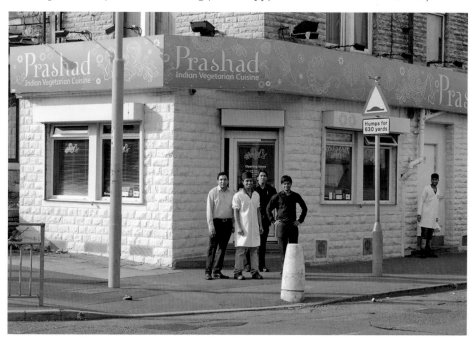

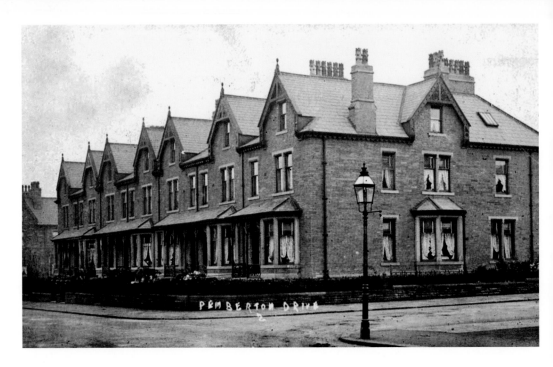

Pemberton Drive, Great Horton, 22 May 1906

Now a heavily populated student area, Pemberton Drive was once the choice of the affluent who wanted to live within walking distance of the city. 'Dearest Amy, Thank you very much for Picture, hope you will like this. I live at the second house down. There is another girl working here, it is nice being away especially for when your day off comes. But it is different from being in business. How is baby getting on? I should like a photo of her and of the children. Remember me to everyone and I hope they are all quite well, keep in touch love to all. Love to you always, Scarlett x'

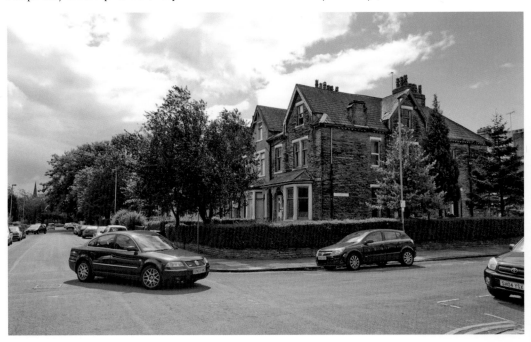

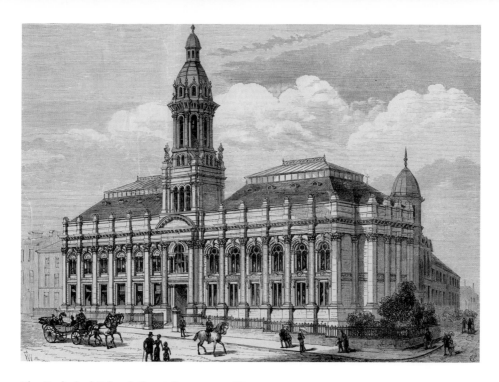

The Technical School, Great Horton, *c*. 1882

It was a great day for Bradford when the Prince and Princess of Wales (the future King Edward and Queen Alexandra) came to open the Technical School on 23 June 1882. Ceremonial arches were erected on the route from Saltaire, where the royal couple were staying with the Salt family at Milnerfields. An exhibition of art, textiles and craftsmanship, depicting Bradford's industry, was laid on at the school for royal approval. Such was the pomp surrounding the event that *The London Illustrated News* ran a full feature on the visit the same week.

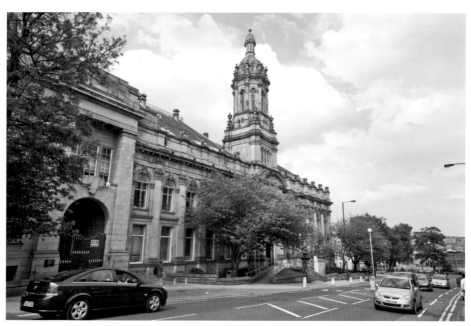

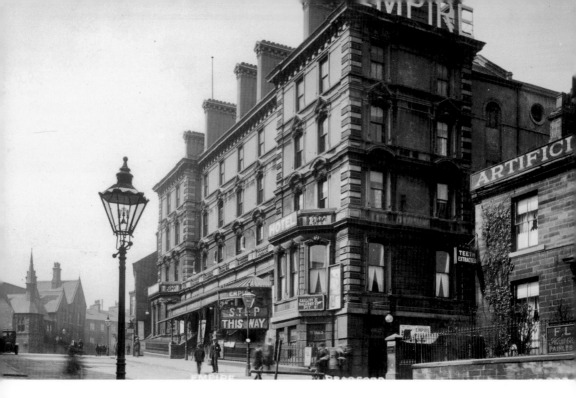

Alexandra Hotel – The Empire, *c.* 1908
The Alexandra Hotel, Great Horton, was certainly an imposing building with its columned entrance and fine architecture. Designed by local architects Andrews and Pepper, it opened for business in 1877. Later the Empire Music Hall was added, where stars of the day such as Stan Laurel and Charlie Chaplin appeared. Unfortunately, all that remains is the footprint of the building, currently in use as a public car park.

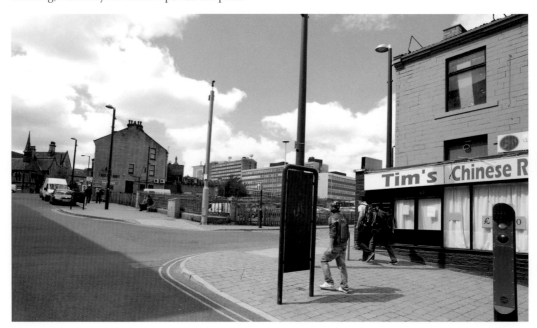

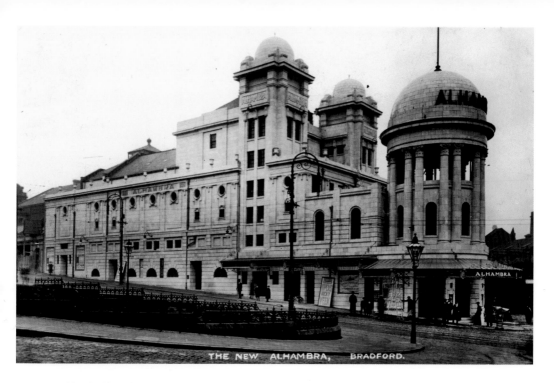

Bradford Alhambra, March 1914
The billboard announces the opening 'next week' as workers attend to last-minute detail work. The Alhambra was built at a cost of £20,000 for theatre impresario Francis Laidler. Little did the bystanders know that the First World War was just four months away. Today the theatre continues to thrive as a touring venue, hosting a wide range of stage shows.

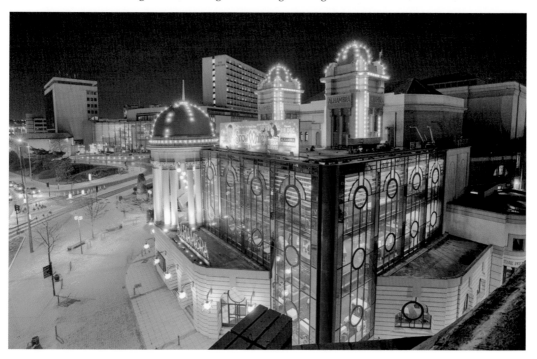

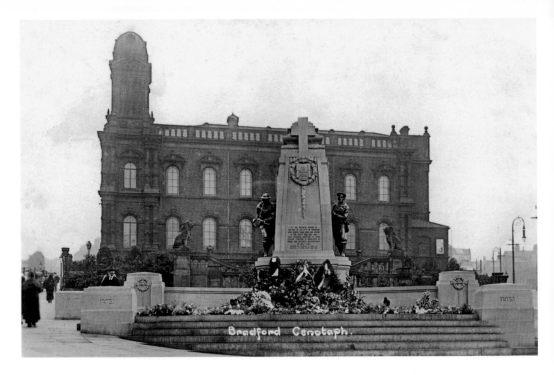

Bradford Cenotaph, *c.* 1923

Looking to the left of the Odeon, we find Victoria Square and in particular the Cenotaph, which was dedicated in 1922 'To The Immortal Honour Of The Men Of The City Of Bradford Who Served Their King And Empire In The Great War 1914–1918'. Sadly, as we know, the memorial was later modified to commemorate the many more Bradford lives lost in the Second World War.

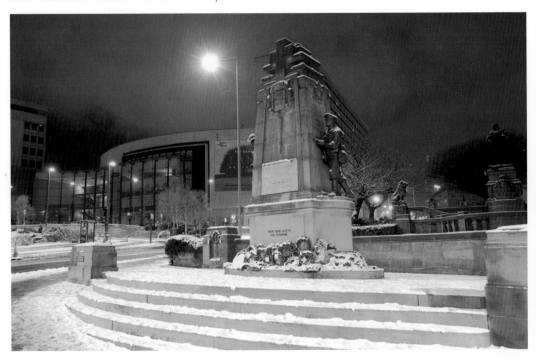

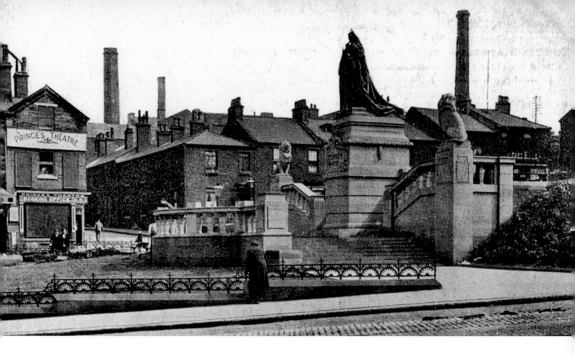

Victoria Square, *c.* **1910**
Above the Cenotaph the Victoria monument stands tall and proud. Alfred Drury's sculpture was unveiled on Wednesday 27 May 1904, by HRH the Prince of Wales (later King George V). It depicts Queen Victoria as she would have been at her Jubilee in 1887. She remains today as she was then, imperiously watching over the evolution of Bradford. Note the Prince's Theatre in the near distance.

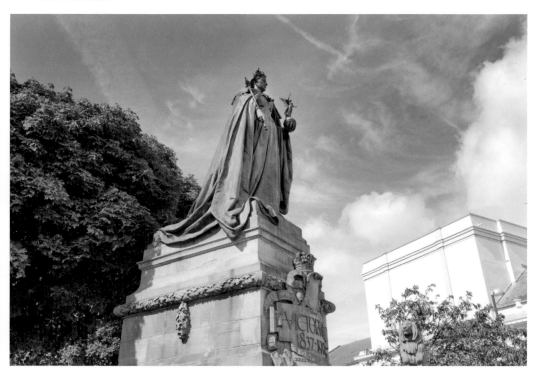

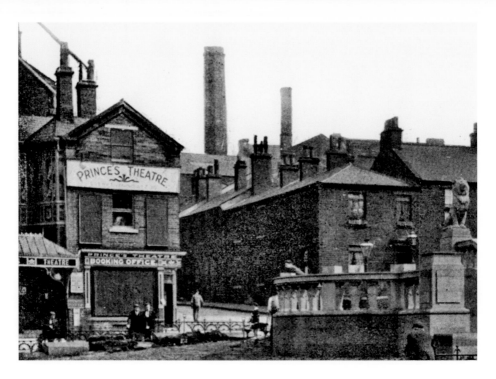

Prince's Theatre, c. 1910
The Prince's Theatre was built in 1876 by Jackson & Langley. This early image was taken following the renovation in 1900. Theatre impresario Francis Laidler had taken on the lease and among the plays premiered to eager audiences was *Summer Night's Dream* by Bradford's very own J. B. Priestley. The theatre closed in 1961, remaining empty until its demolition in 1964. It eventually made way for what is now the frontage of the National Media Museum.

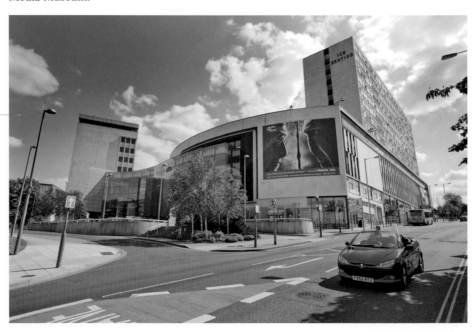

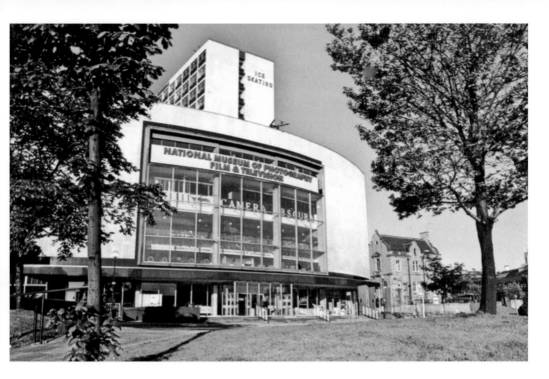

National Museum of Photography, Film & Television, *c.* 1990
Originally the National Museum of Photography, Film & Television, this unique institution opened to the public in June 1983. It boasted the UK's largest IMAX cinema – later modified to show 3D films. To this day, the museum draws visitors from around the world to its spectacular film festivals. I am proud to have covered the 17th Annual Bradford International Film Festival in 2011 as the official photographer. Renamed the National Media Museum in 2006, this is without doubt Bradford's modern day jewel in the crown.

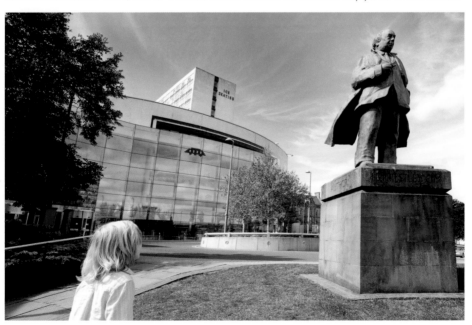

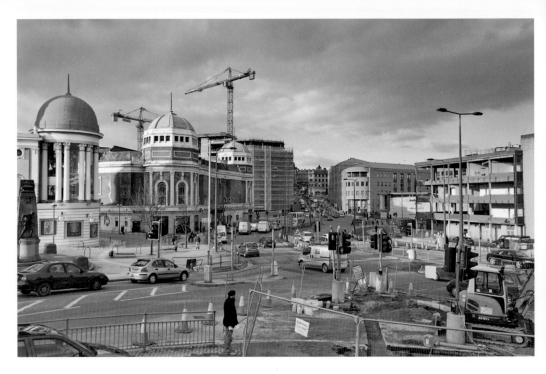

Victoria Square – Prince's Way, February 2010

Looking back from the National Media Museum, we take in Victoria Square, Prince's Way and beyond. In just over a year, we can see for ourselves how rapidly Bradford is regenerating. To the right we see the demolition of the police station to make way for the City Park. The Odeon remains the same, awaiting an uncertain future, but the new Southgate development behind, with its tower cranes reaching for the skies, is symbolic of a new and exciting Bradford.

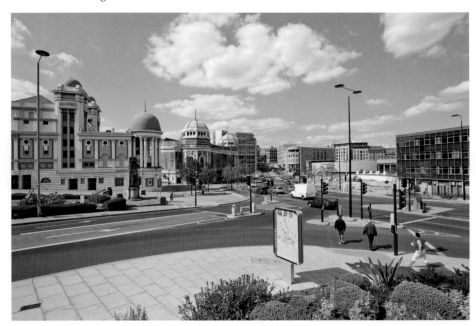

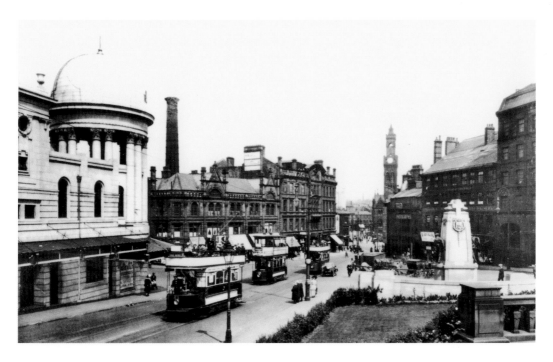

Victoria Square – Tyrrel Street, *c.* 1923

Post-war Victoria Square from Victoria's eyes. No longer do the trams pass in quick succession by the now-established Alhambra Theatre. With the exception of the Cenotaph, the Alhambra, and City Hall, everything has been swept away in the spirit of Bradford's development and regeneration. Some people would prefer the 1923 view to the less energetic scene we see today. Without hesitation I raise my hand in agreement.

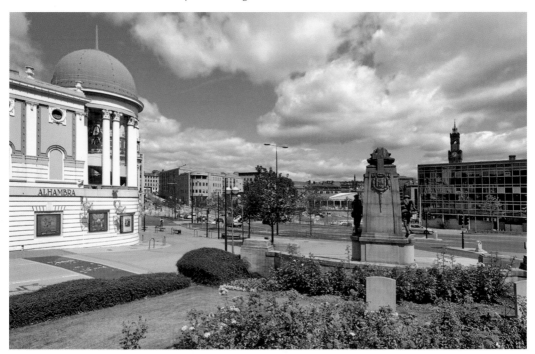

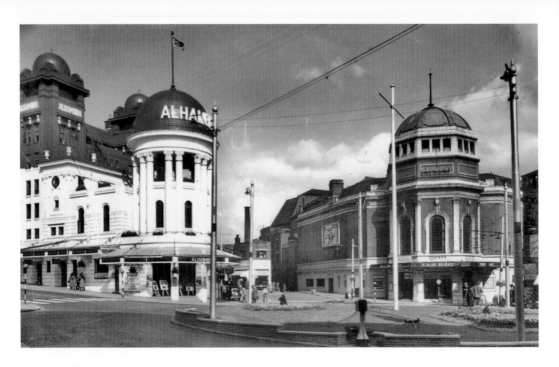

Bradford Odeon, c. 1953

Originally the New Victoria and later renamed the Gaumont, before ultimately becoming an Odeon in 1969, this picture palace was built on the site of Whittaker's brewery. When it opened on Monday 22 September 1930, it boasted the third-largest cinema auditorium in England. Its twin green-domed entrances and impressive façade complemented the similarly domed Alhambra Theatre next door. Sadly, the Odeon closed in 2000 and the building has remained empty ever since, facing a most uncertain future.

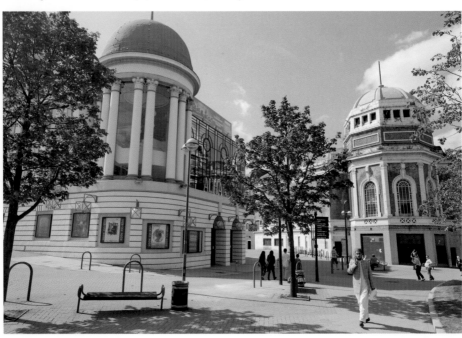

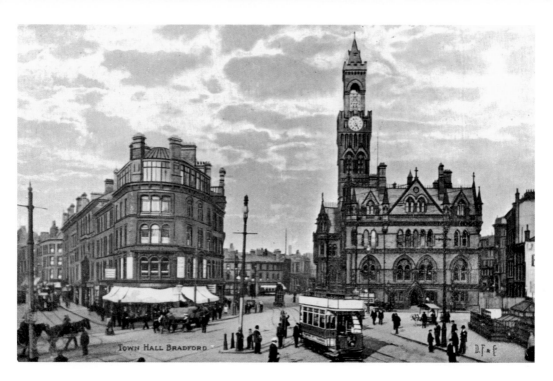

City Hall from Prince's Way, *c.* 1904

Crossing Prince's Way (formerly New Victoria Street) we find ourselves viewing a very different scene from that which existed in 1904. Currently under construction in 2011, is Bradford's 6-acre City Park which, when completed, will contain the largest water feature of any UK city. The park's principal point of interest, the mirror pool, will reflect City Hall, as well as having more than 100 fountains with light, mist and sound effects.

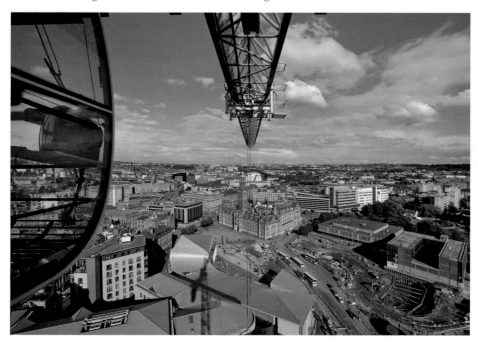

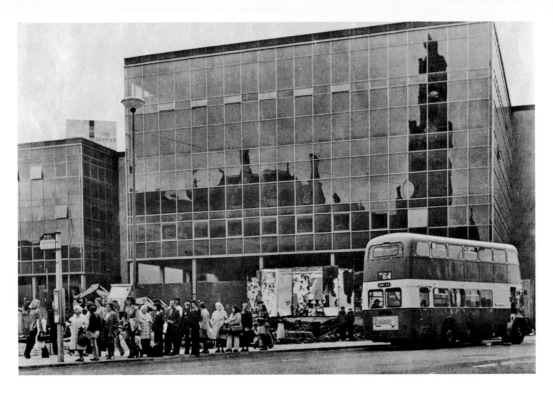

The New Police Headquarters, *c.* 1974
When opened by the Queen in 1974, the new headquarters were hailed as the most modern in the country, and the walls were described as 'fascinating' because they gave off a distorted and wobbling reflection. Unfortunately for the building, the fascination only inspired us to keep it for twenty-six years! It was torn down in part last year to make way for the new City Park.

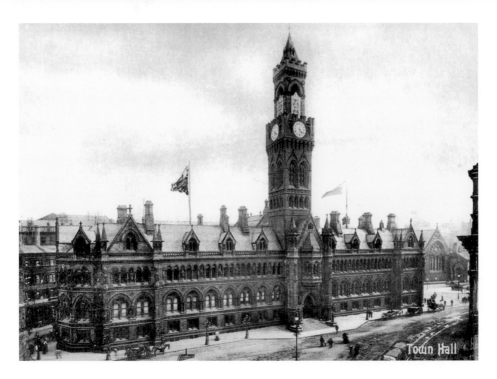

City Hall, *c.* 1905

Designed by Bradford's most famous architects, Lockwood and Mawson, City Hall (as it was to become) was opened in September 1873 by the Mayor, Alderman Matthew Thompson. So grand was the Italianate design, inspired by the Palazzo Vecchio in Florence, that *The Illustrated London News* featured the opening ceremony on its front page. Today City Hall stands as a true representation of Bradford's nineteenth-century wealth and industrial power.

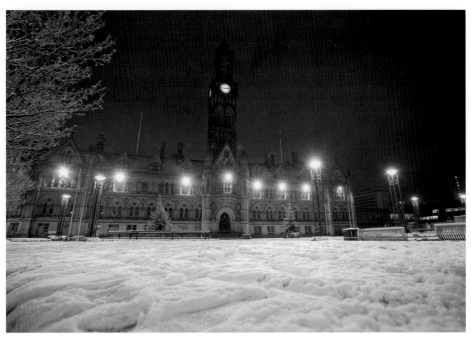

The Victorian Police Station, *c.* 1888
In the basement of City Hall remains the old Victorian police station. Today the cells (with their doors laid open) contain election literature. Back in nineteenth-century Bradford, this formidable place was under the control of Chief Constable James Withers (who served from 1873–1894). The cells held many serious criminals, including John Jackson, the so-called 'Manchester Murderer', who had stabbed to death a warder at Strangeways, Manchester and was destined for the gallows. After the murder Jackson escaped to Bradford, where he was identified and arrested despite giving a false name. He was duly hanged in June 1888.

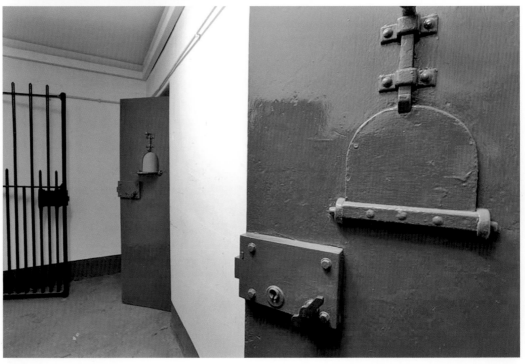

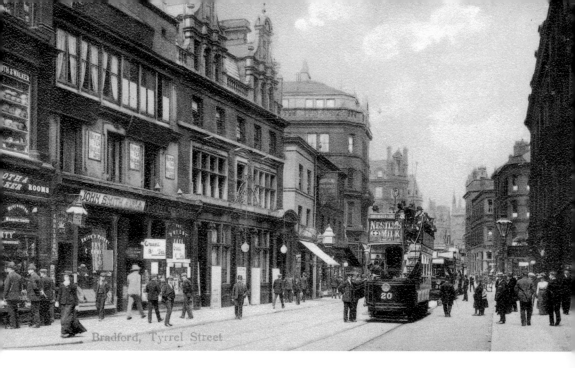

Bradford, Tyrrel Street

Tyrrel Street, c. 1907

This once bustling street, which ran from below the Alhambra and across the front of City Hall, now forms part of Centenary Square. At the time of writing (summer 2011) the Square is undergoing transformation into the City Park. Swept away are many familiar sights, such as the building just before the Grosvenor Billiard and Dining Rooms (foreground: left of the tram, red sign above the door). Thankfully those in the distance remain.

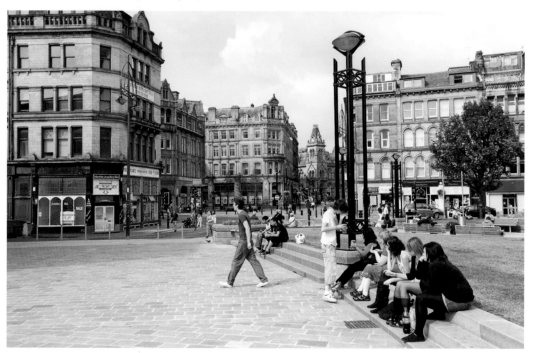

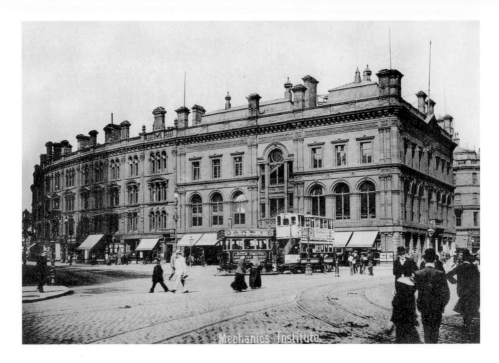

Mechanics' Institute, c. 1905

The man chosen to open the magnificent Institute in 1872 was the Rt. Honourable W. E. Forster (inset). The building contained shops, a floor-level newsroom with an extensive library above, as well as a lecture theatre for 1,500 people. The upper floor was an elegant restaurant. The Institute provided a social centre in the heart of the city. The Second World War led to hard times and many such societies closed. However, the Institute was to carry on functioning into the 1960s, before eventually disappearing off the map in the mid-1970s.

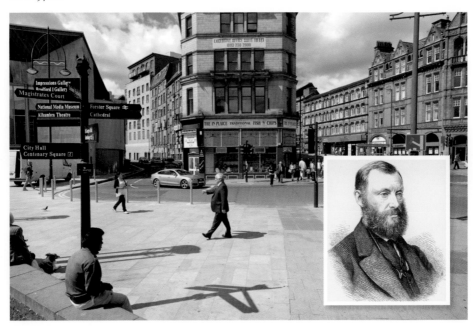

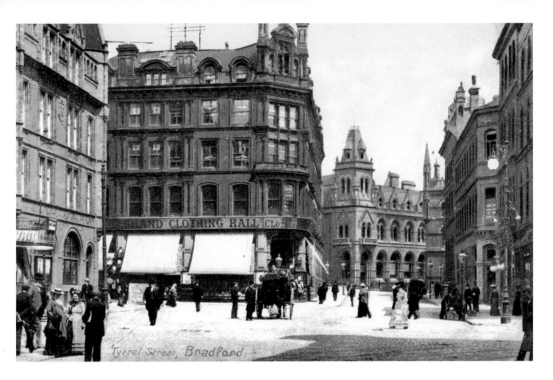

Tyrrel Street, *c.* 1903
Essentially, this is all that remains of Tyrrel Street, looking from where the Mechanics' Institute once stood on Bridge Street. Despite the passing of 108 years between images, the area and buildings remain largely the same, although the Grand Clothing Company has metamorphosed into Lloyd's Bank (centre). Similarly the Yorkshire Banking Company has given way to NatWest (in the middle distance), and KFC has found a home in what was the grand Brown & Muff's department store, facing the bottom of Ivegate.

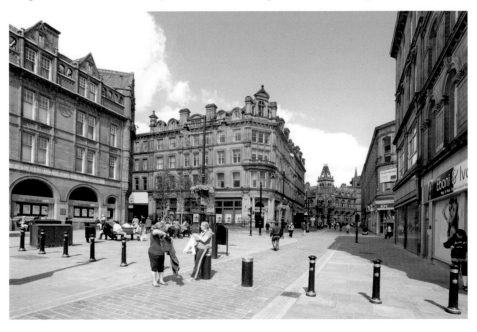

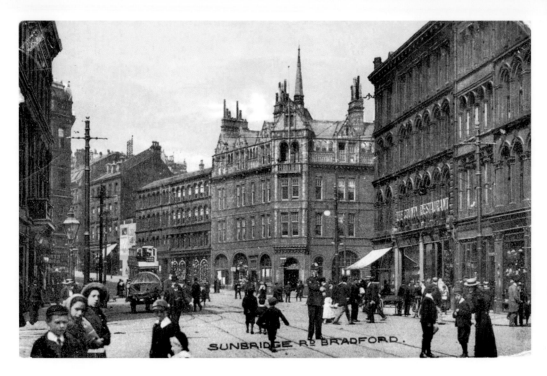

Sunbridge Road, *c.* 1907

Despite this early image being described as Sunbridge Road, it is actually Bridge Street that is pictured in the near foreground. To the left is the Mechanics' Institute and to the right (by the green lamppost) is Rimmington's Chemists. To this day Rimmington's is still in business, though it is no longer a family-run concern. During the latter part of the nineteenth century, Felix Marsh Rimmington served Bradford as its resident analytical chemist and gave forensic evidence at many major trials.

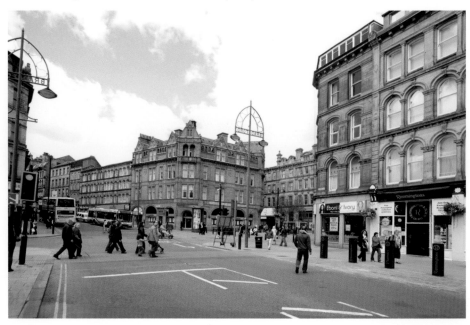

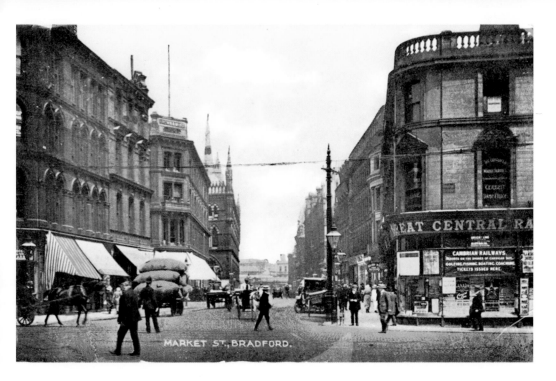

Market Street, *c.* 1919

A view of the junction of Bridge Street, with Market Street directly in front. The Great Western Railway booking office (to the right) was well placed for the passing trade back in post-First World War Bradford. A policeman stands in the middle of the road, possibly directing traffic, which is clearly dominated by horse-drawn transportation. There is, however, a motorised vehicle partly obscured by the lamppost at mid-right.

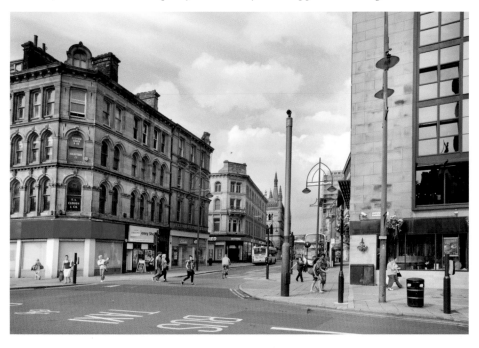

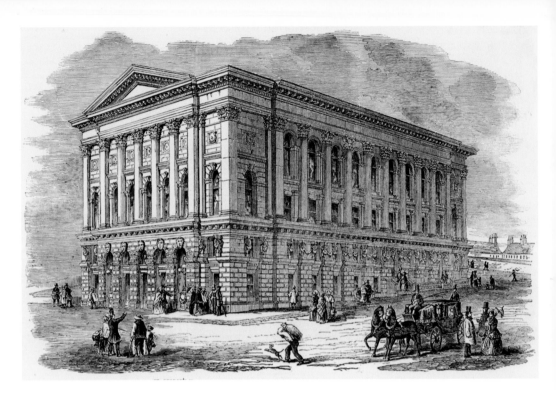

St George's Hall, Bridge Street, *c.* 1853

Designed in a neo-classical style by Lockwood & Mawson, the plans for Bradford's Victorian concert hall were among twenty-two designs submitted during a competition in 1849. The opening of the hall by Queen Victoria and Prince Albert took place on 29 August 1853 and was extensively reported in *The London Illustrated News*. Over the decades many famous names have appeared at St George's Hall, including the great Charles Dickens, who in 1854 gave his first-ever reading of *Bleak House* here.

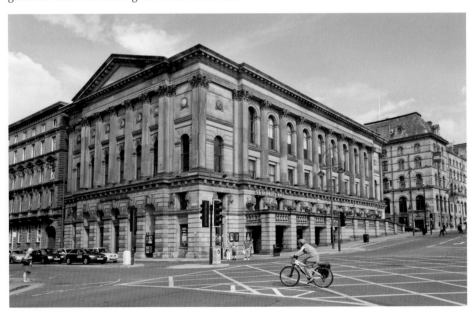

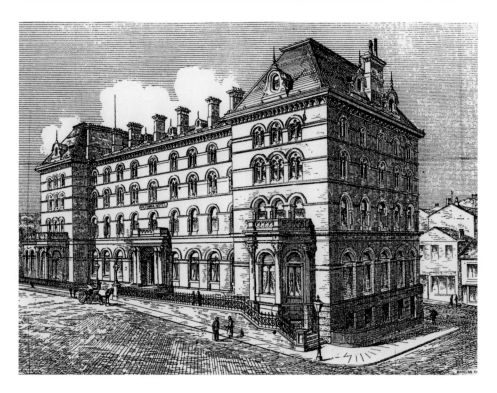

Victoria Hotel, Bridge Street, *c.* 1888

Prior to the hotel being built next to St George's Hall in 1867, Bradford lacked superior accommodation suitable for distinguished visitors. Originally, the hotel (also designed by Lockwood & Mawson) adjoined the Lancashire, Yorkshire & Great Northern Railway Company. While the heady days of steam power are long gone, the hotel still provides fine city-centre accommodation.

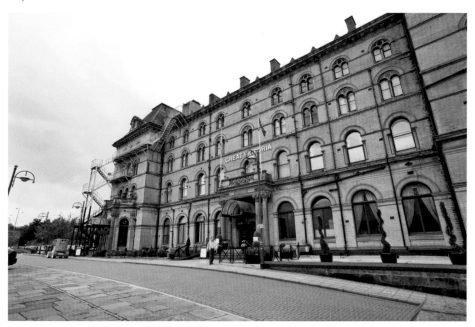

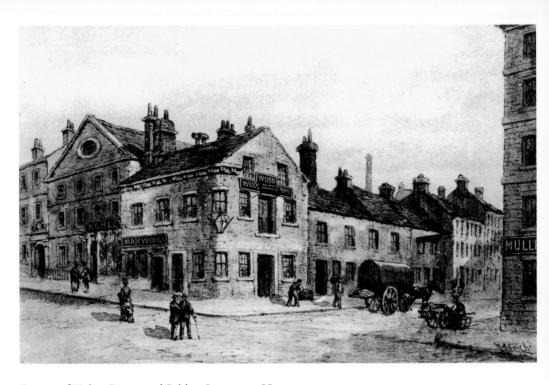

Corner of Union Street and Bridge Street, *c.* 1880

Moving up Bridge Street towards Nelson Street, we arrive at the junction of Union Street. This image from 1880 depicts Marwood's, a Dickensian name if ever there was one! At the time, Edward Marwood was a cork manufacturer. It is interesting that nothing remains of the original buildings that would lend a clue as to the location of this particular old image.

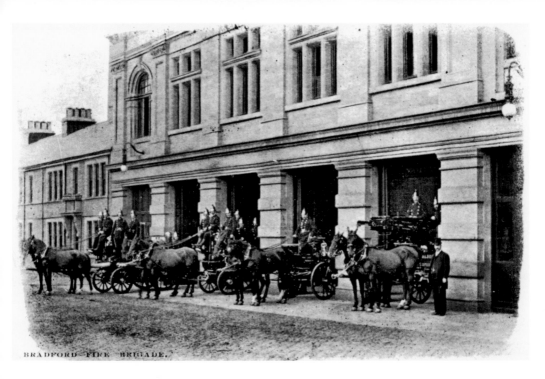

City of Bradford Fire Station, Nelson Street, *c.* 1904

The fire station of 1904 is so much more attractive than its modern equivalent, and it is a shame that the fine old building was not renovated rather than being replaced by this uninspiring substitute. However, given that the new one has been closed for some time, perhaps the argument is purely academic. Interestingly, back in 1904 the Chief Constable of Police also doubled as Captain of the Fire Brigade.

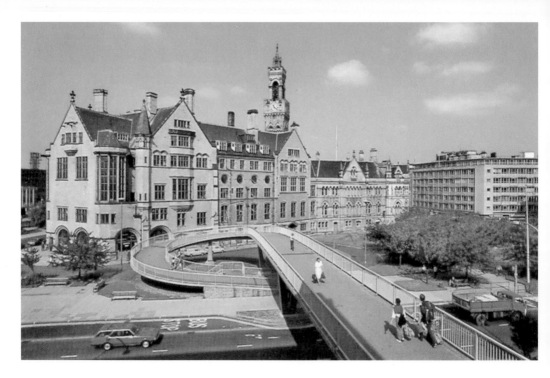

Hall Ings Footbridge, c. 1985
The major difference between the two images is the absence of the footbridge in the later photograph. Its demolition in October 2009 represented one of the first stages of the City Park project's transformation of the area surrounding City Hall. The bridge's centre span – weighing 80 tons – was the first section to be removed, on 4 October 2009.

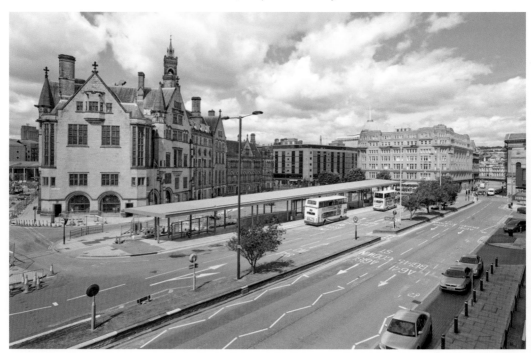

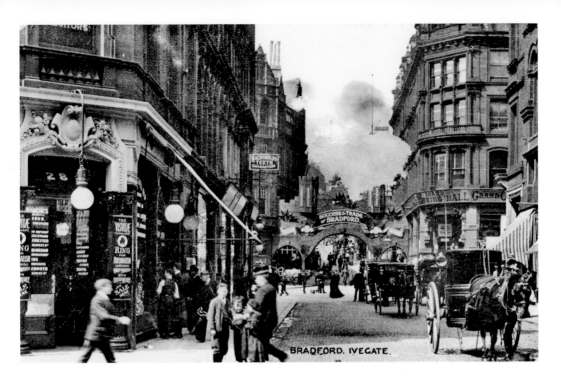

Ivegate from Market Street, *c.* 1904

As we come from Bridge Street and head down Market Street, let us turn and look up Ivegate. The foreground of this scene from 1904 is decorated for the Bradford Exhibition to celebrate the opening of Cartwright Hall. The Abyssinian Gold and Jewellery Company, to the left, is clearly popular with window shoppers. Today's image plainly shows a dramatic decline in this old thoroughfare.

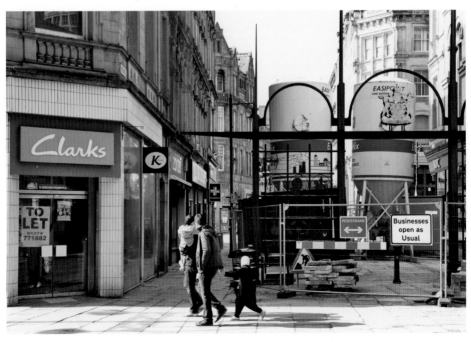

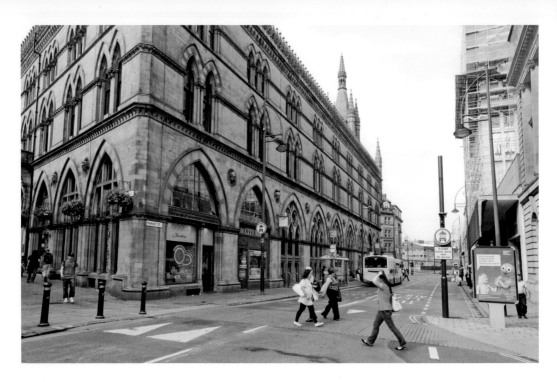

Market Street, *c.* 1904

Moving down Market Street, we come to the old Wool Exchange, once the centre of Bradford's industry. The world's woollen industry was profoundly influenced – if not controlled – from this building. Today the arches have been utilised for various retail shops. In the distance can be glimpsed the Midland Railway Station.

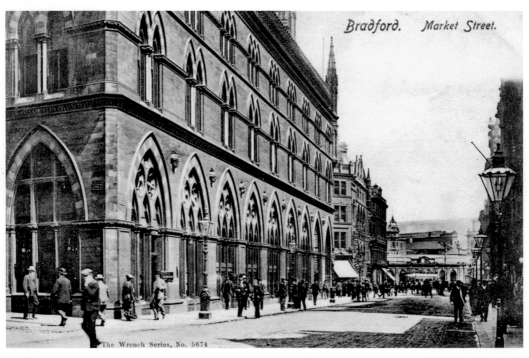

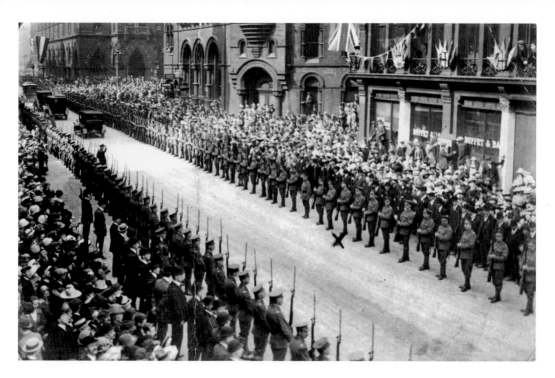

Bradford Pals, Market Street, *c.* 1915

Here is Market Street, looking back towards Bridge Street. This image, from 1915, shows Tommies lining the street and the public standing quietly behind, as four motor vehicles head towards the Town Hall. Note the 'X' to the middle right. The text on the rear of the card reads: 'FN taken in action whilst with the Pals, Grandpa England's last hope (God help her) X this is me (amen).'

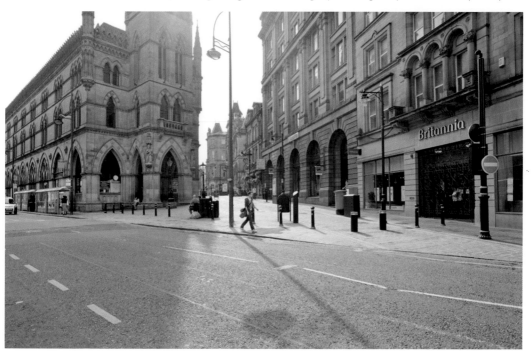

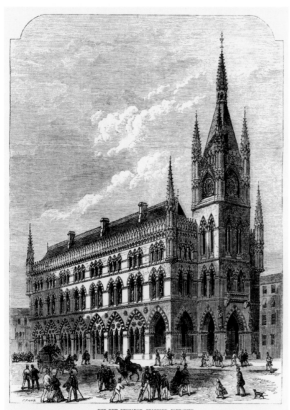

THE NEW EXCHANGE, BRADFORD, YORKSHIRE.

Wool Exchange, *c.* 1867
The foundation stone was laid by the Prime Minister, Lord Palmerston, on 11 August 1864, with much pomp and ceremony. The design was by Lockwood & Mawson, the architectural style being Venetian Gothic with some Flemish influence in the tower. The Exchange opened in March 1867 and was featured in *The Illustrated London News* at the time. The Exchange now houses Waterstone's bookshop – a repository of knowledge in perfect harmony with its grand past.

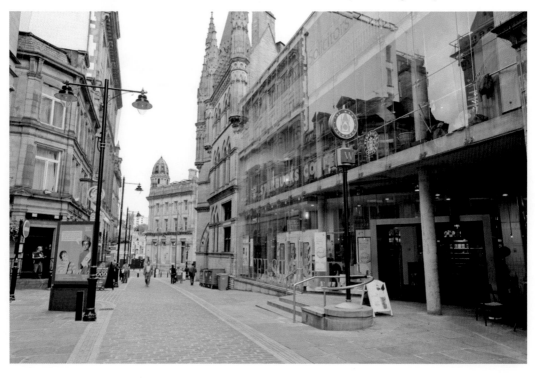

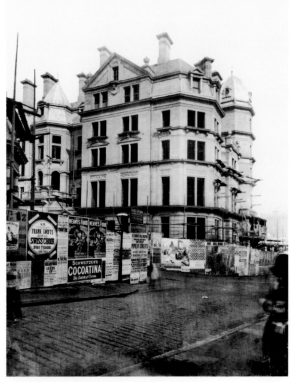

Midland Railway Hotel, *c.* 1889
This image, taken from lower Kirkgate, takes us back to 1889. The Midland Railway Hotel is nearing completion; frameless windows look out sightless whilst the billboards are awash with contemporary advertising. The hotel, designed by Charles Trubshaw, was to open in June 1890. Offering a superior quality of service that is maintained to this day, it has often been the choice of the rich and famous, and welcomed every Prime Minister up to and including Harold Wilson.

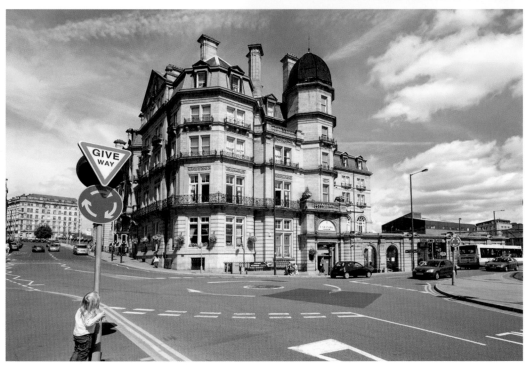

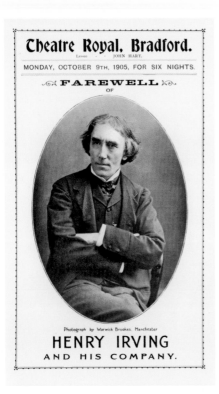

Theatre Royal, Bradford.
Lessee · · JOHN HART.

MONDAY, OCTOBER 9TH, 1905, FOR SIX NIGHTS.

FAREWELL
OF

Photograph by Warwick Brookes, Manchester

HENRY IRVING
AND HIS COMPANY.

Sir Henry Irving, Midland Hotel, 13 October 1905
'Into Thy hands, O Lord. Into Thy hands,' were
the final prophetic words of Sir Henry Irving, on
stage at the nearby Theatre Royal. He collapsed
and died, minutes later, at the Midland Hotel.
Irving had just played the role of the chancellor
and archbishop in Tennyson's *Becket*, as part of
his aptly named Farewell Tour. Irving (born John
Henry Brodribb) was the greatest and most fêted
actor of the Victorian age and when Bradford
mourned the whole world mourned with us.

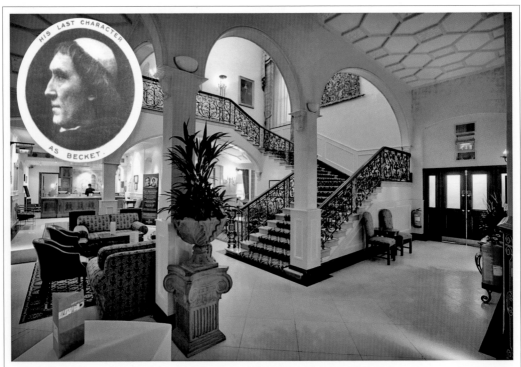

THE MARBLE HALL OF THE MIDLAND HOTEL, BRADFORD.
Where SIR HENRY IRVING suddenly received HIS LAST CALL. Oct. 13th, 1905

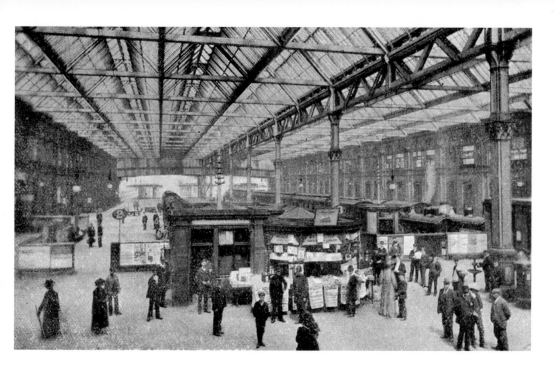

Midland Station, Forster Square, *c.* 1908

The railway first came to Bradford in 1846, though the town had been campaigning for it since 1830, only to meet with rebuff. Nevertheless, once it came the town rapidly expanded. This wonderful image from a time when the steam locomotive was king brings home to me just what Bradford has lost through change. The station shown here was completed in May 1890 – the city's third such station in forty-four years.

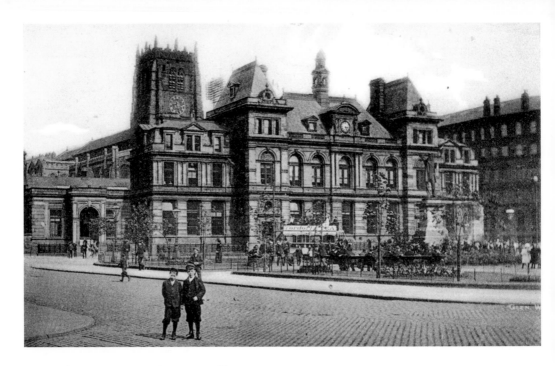

St Peter's House, Forster Square, *c.* 1887

Situated just below the parish church and taking three years to complete, the new General Post Office was a sight to behold. Messrs Potts & Sons, Leeds, provided the handsome 12-foot clock face. Great attention was paid to florid carved work and superficial enrichment in the architecture – a good job too, otherwise this fine piece of Victorian architecture might just have suffered a similar fate to that of nearby buildings.

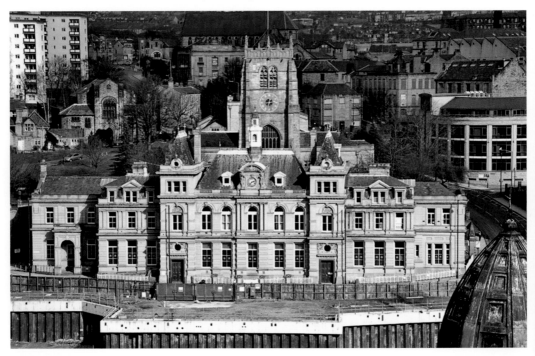

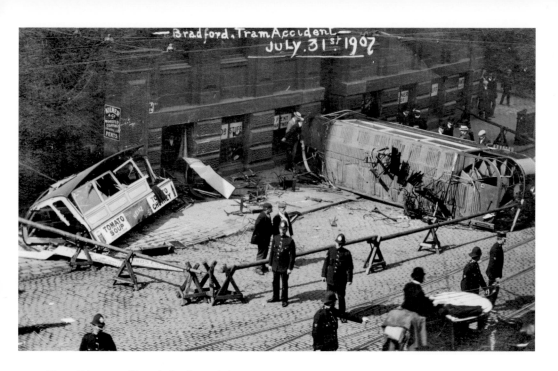

Tram Disaster, Church Bank, 31 July 1907

Joseph Dover, one of the Corporation's most experienced drivers, found himself in a situation beyond his ability when the brakes on Tram 210 inexplicably failed. While descending Church Bank, the normally applied 4-mph speed limit went out of the window, as the tram accelerated out of control, coming to rest in pieces on Well Street. Surprisingly no one was killed, although fourteen people were injured, presenting onlookers with a terrible sight.

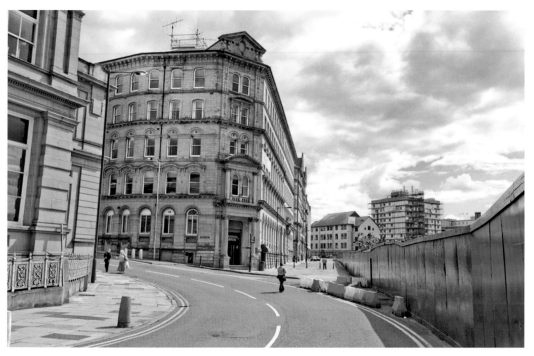

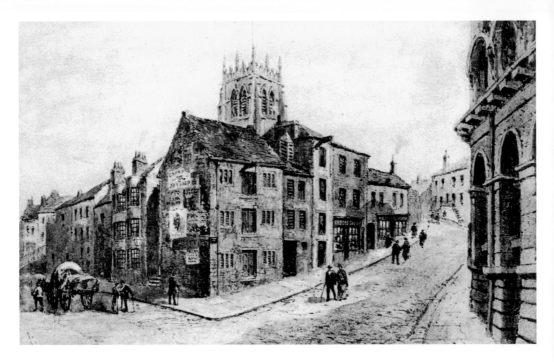

Church Bank, *c.* **1870**

This photograph looks almost like a scene from a rural village, rather than a fast expanding town. This is Church Bank from Well Street, prior to the clearance which made way for St Peter's House. In the middle distance James Rhodes, wool-stapler (dealer in wool) and top maker displays his goods at No. 9. Further up the hill, on the right, was the location of the first local workhouse, established in 1783.

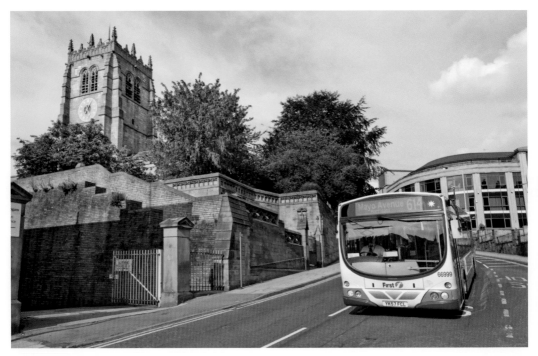

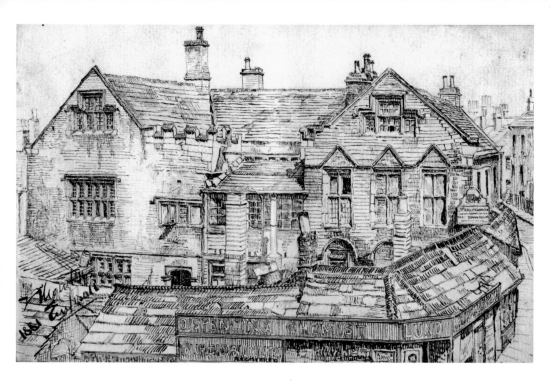

Paper Hall, Barkerend Road, *c.* 1881

Following Church Bank to Barkerend Road, we find Paper Hall – drawn in pen and ink in 1881 by Thomas Thornton Empsall, one of the founders of the Bradford Historical and Antiquarian Society. The Hall, reputed to be the oldest house in Bradford, was built around 1643 and was the location of the first Spinning Jenny in the town. Empsall's illustration shows cottages where now the A650 Shipley Airedale trunk road lies. Hugging the hall is Lund's Dispensing Chemists, long since removed, creating a pleasing aspect.

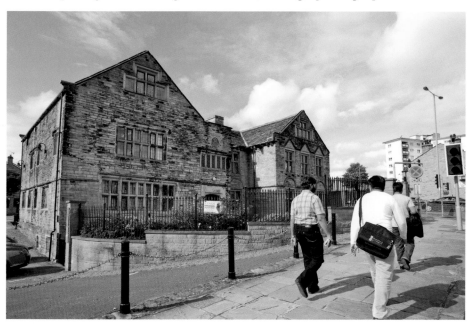

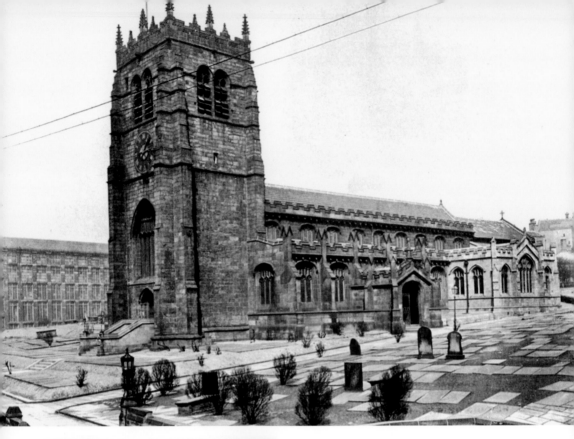

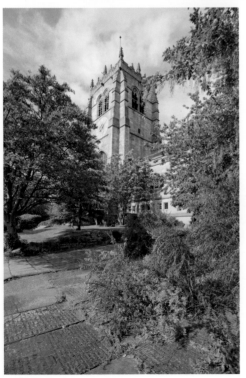

Bradford Cathedral, *c.* 1906
For more than a thousand years Bradfordians have worshipped at St Peter's. Designed in a rugged, uncompromising style the old church stands watching over us all. She has witnessed the historic glories, the poverty, tales of want, the legends of wealth and plenty. She has given shelter and protection in times of turmoil. But most of all, she has provided peace, hope and prayer for thousands of parishioners. Today the cathedral represents a space of calming retreat in a city alive with change.

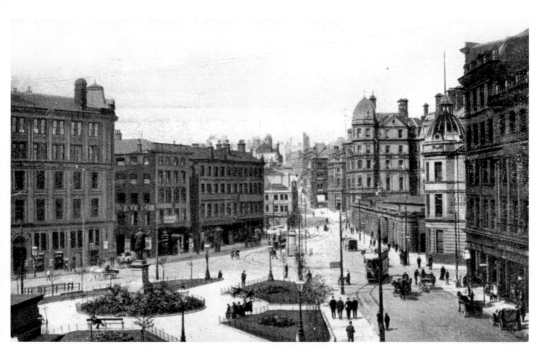

Forster Square, c. 1906

Coming down Church Bank we look across the wasteland that was once Forster Square. The 1906 image shows a well-ordered Edwardian scene; today everything in the foreground has gone, to be replaced by a vast crater awaiting the arrested development of a new shopping centre. The statue of the Rt. Honourable W. E. Forster has once again been packed off for safe keeping. Only the Midland Hotel and a few other buildings in the distance remain.

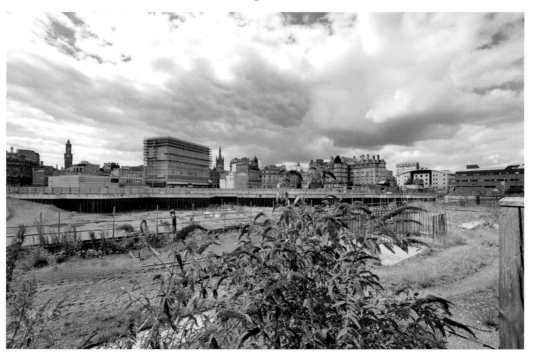

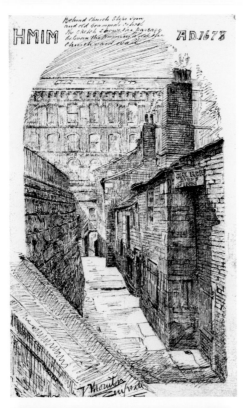

Church Steps, *c.* 1881

Thomas Thornton Empsall gives us a further
insight into old Bradford with this image
drawn in 1881. It captures the scene just a
year before the clearance of Broadstones in
readiness for the new Forster Square. The
scheme involved the demolition of the church
steps on the site of St Peter's House (shown
earlier). Much sentiment surrounded the
old passageway, more so than the wholesale
demolition of neighbouring properties. Today,
the new steps present a romantic picture of
late-Victorian Bradford.

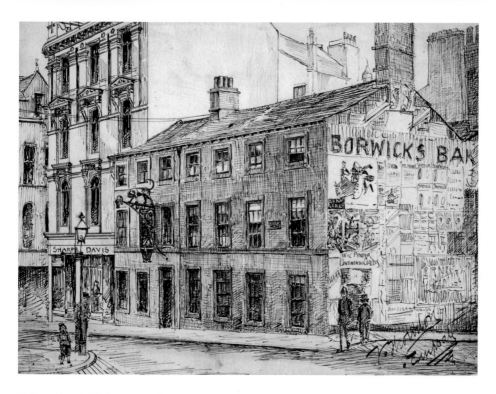

Talbot Hotel, Kirkgate, *c.* 1875

Walking back past the Midland Hotel we find our way to lower Kirkgate. Pictured is the Talbot Hotel prior to rebuilding in 1879; the old building dated back to 1677 and was once a famous coaching inn. The new Talbot, designed by Andrews & Pepper, still survives but closed in March 1974. Sadly, the Talbot dog which dominated the main entrance is long gone, having disappeared shortly after closure. Today the lower floor is occupied by Orange.

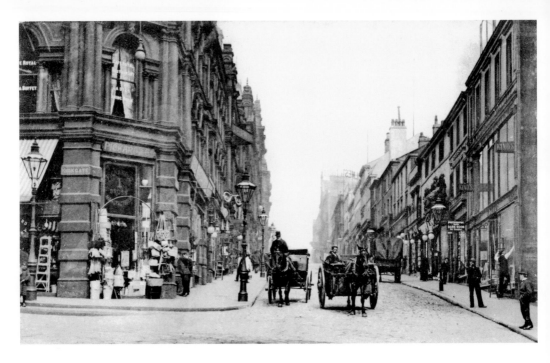

Darley Street from Kirkgate, *c.* 1906

Looking up from Kirkgate, shoppers peruse the goods on display at Pickard's, manufacturers of fine brushes, while the Café Royal advertises a ladies-only dining room above. Horse-drawn vehicles navigate the cobbles as the predominantly male population goes about its daily toil. Over one hundred years later, Darley is still a busy shopping street, despite much change. Pictured is the Continental Market held every August.

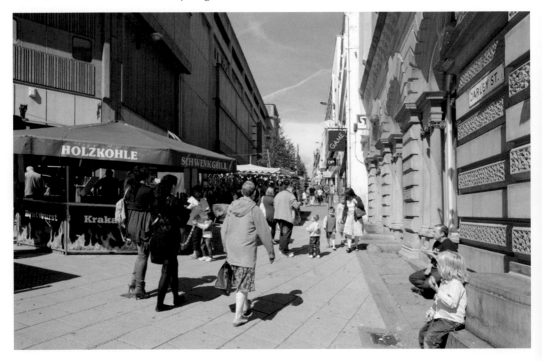

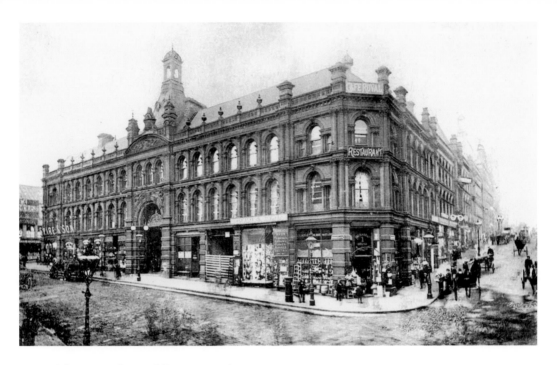

Kirkgate Market Buildings, *c.* 1906
Architects Lockwood & Mawson once again won through to design this finely-sculpted market building. Although the first part of the covered market opened in 1871, it would be another seven years until the building was finally completed. The magnificent shopping area served Bradford admirably for nearly a century before it was closed in 1973, being replaced with its gaunt and heavy concrete substitute. The loss of this fine building would surely make Mawson himself weep in frustration.

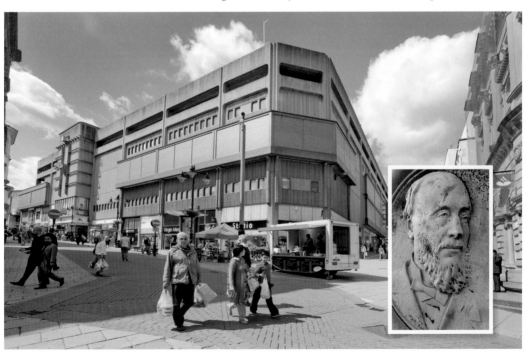

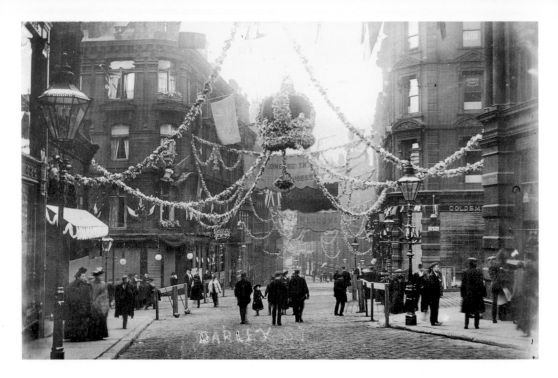

Darley Street, *c.* 1904

4 May 1904 was a day long-remembered by the townsfolk of Bradford; the Prince and Princess of Wales (later King George V and Queen Mary) opened the Bradford Exhibition at Cartwright Hall. Here we see Darley Street, impressively decorated for the occasion; spectators await eagerly by the bollards, while two heavily dressed Edwardian women look on. The Royal procession travelled down Darley Street on its way to Victoria Square via Market Street.

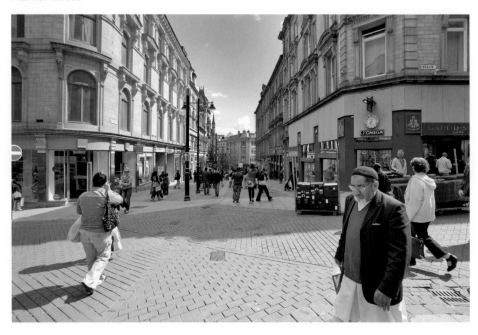

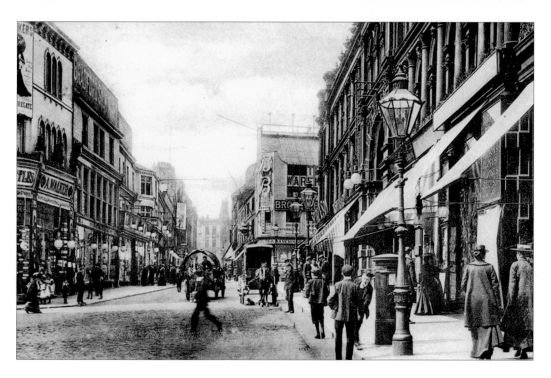

Kirkgate, c. 1903

Looking towards the top of Ivegate. On the wall of the market building to the right, the sign alerts shoppers to the wares of Burnside Brothers, fancy draper's. On the left, Walker's Mantle Dealers adjoin Rendall's draper's. The large Brooke Bond tea warehouse juts out into the road making its presence known in the middle distance. Kirkgate was certainly a busy shopping precinct and to its credit remains so today, with contemporary retail shops lining this ancient part of Bradford.

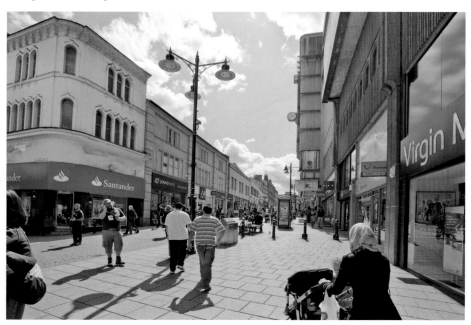

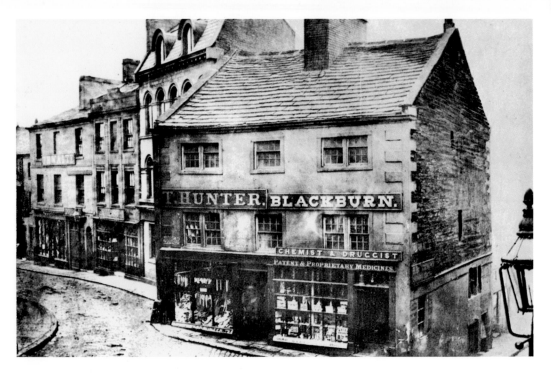

Ivegate Junction with Kirkgate, *c.* 1860

Straight out of Charles Dickens' lifetime, Bailey Blackburn, chemist and druggist, offers his patent and proprietary medicines alongside Thomas Hunter, tailor and draper, situated at the top of Ivegate. Despite appearances and the passage of time much still remains today, although the exceedingly narrow Kirkgate is now a much wider shopping area.

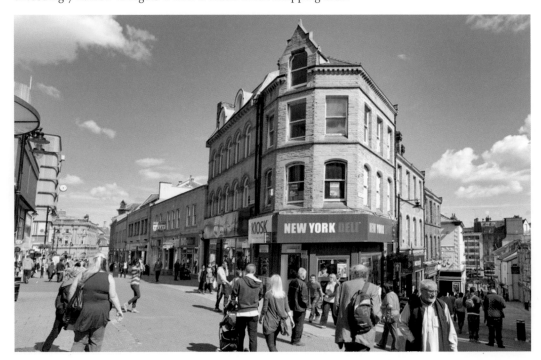

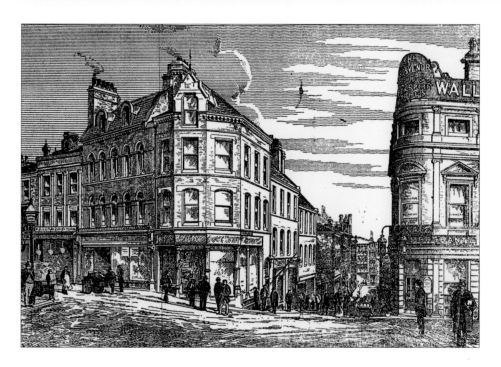

Ivegate Junction, 1888

Moving on twenty-eight years, Bailey & Thomas's premises have undergone clearance, thus widening the entrance to Ivegate. At the time the street was one of the main arteries into the town and an excellent business stand despite its steep gradient. To the right is the old Spotted Ox, then called the Grosvenor, selling an extensive range of wines and spirits. The house is of special interest, having subterranean cellarage extending from under Ivegate to beyond Sunbridge Road.

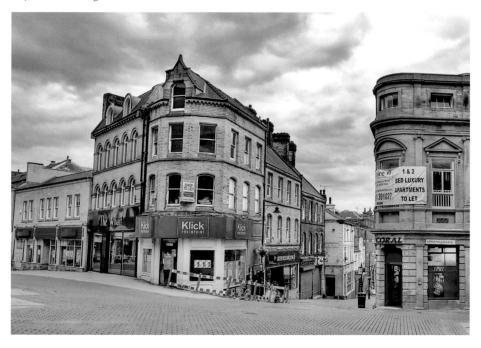

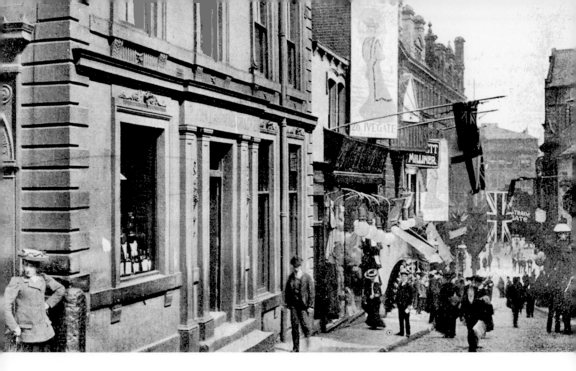

Ivegate, 1904

Let us now take in middle Ivegate. The year is 1904 and the street is decorated for the Royal visit. To our left, the Edwardian woman posing for the camera stands by John Barraclough's Wine and Spirit Merchants, (the building still serves alcohol to this day). Lower down are the business premises of Thomas Ford, mantle dealer, and virtually opposite is Ye Old Crown. Market Street can be seen in the long distance beyond the flags.

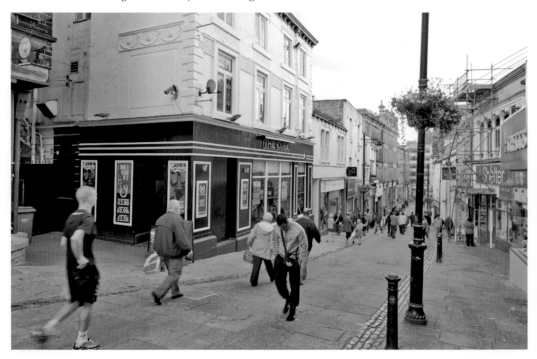

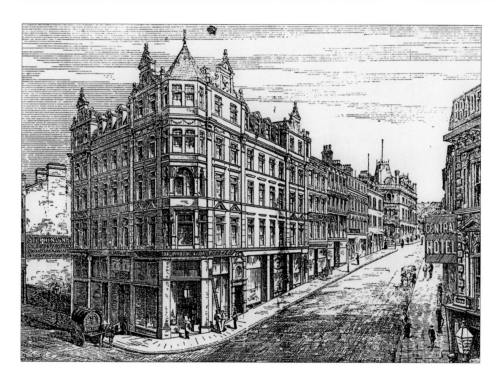

New Westgate, 1888
Illustrated is the first complete section of the new Westgate. The year is 1888 and things were happening in Bradford. The expenditure on improvements was to cost the borough in the region of £250,000 – an extremely large sum in those days. Prior to the improvements, old Westgate struggled to accommodate even the pedestrians on market days. Today the block is a mixture of the renovated and the uncared for.

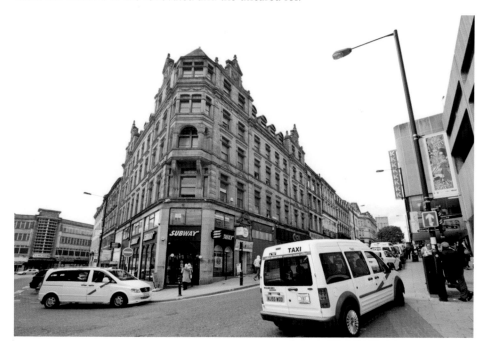

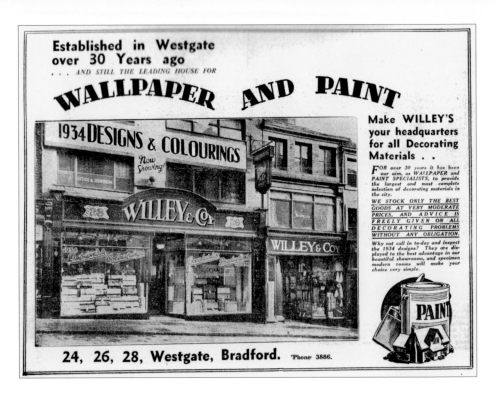

Willey's Westgate, *c.* 1934

Moving forward in time and looking across the road from the new Westgate buildings we have 24, 26 and 28 Westgate, the premises of Willey & Co, wallpaper and paint specialists who had successfully retailed their goods in Bradford since 1904. The shops are now long gone, swallowed up in the development of the new Arndale Market (now known as Kirkgate Centre) although, if my memory serves me well, Willey's did relocate to the new market where it traded for some time.

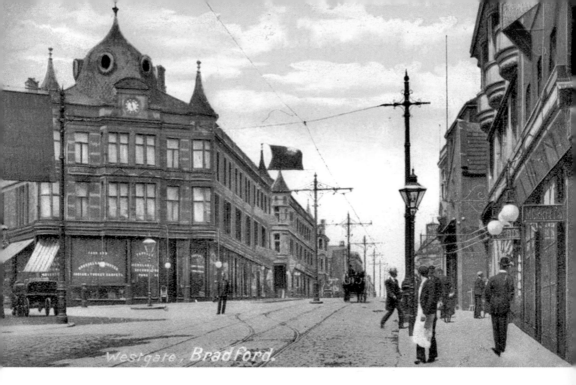

Westgate, c. 1904

Crossing Godwin Street, we find Morrell's grocer's. They occupy numbers 46 and 48 Westgate. Outside, a young man wearing a white apron looks towards the policeman standing in the road. To the left the rather grand looking building with the ornate roof completes a well ordered Edwardian street scene.

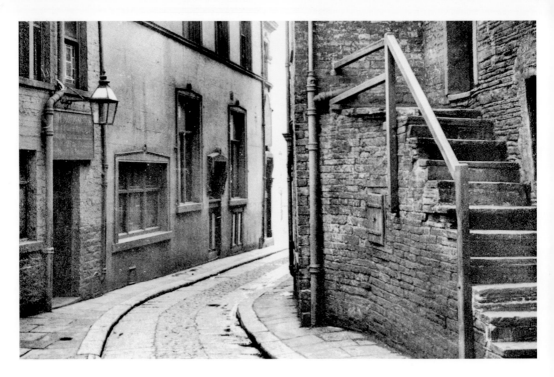

Jamesgate, *c.* 1930

This old thoroughfare links Westgate to John Street. Here are two old Bradford public houses: the Boy and Barrel to the left, the Pack Horse to the right. Sadly the old Pack Horse was demolished in the 1960s and replaced with the appropriately named New Pack Horse. The passage of time has had little effect on the Boy and Barrel, almost caught in a time warp and still serving ale.

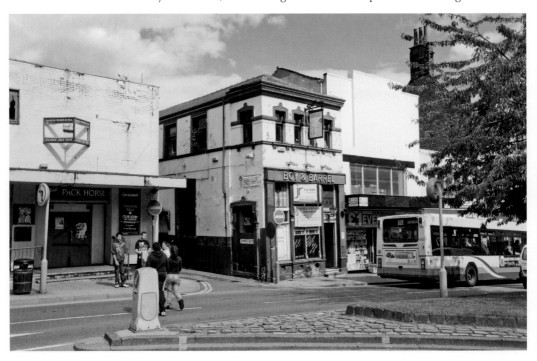

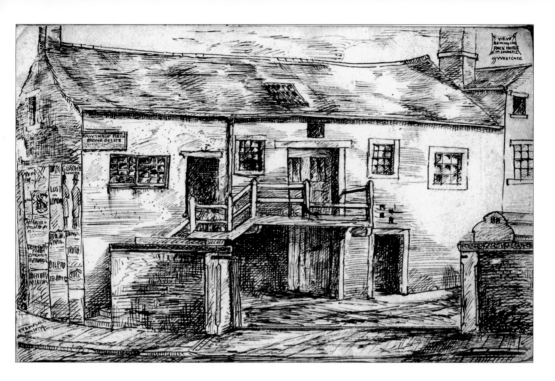

The Old Pack Horse Inn, *c.* **1881**

On 25 October 1870 the old inn was the scene of a shocking murder. Employee Thomas Leach, forty-five, known locally as 'Water Tom' (being a fireman) was stabbed through the heart by Patrick Riley, thirty-six, during a disturbance. Riley was later sentenced to hang for the crime but was reprieved and transported for life instead. Water Tom is buried at Daisy Hill Chapel where he has a memorial to his murder.

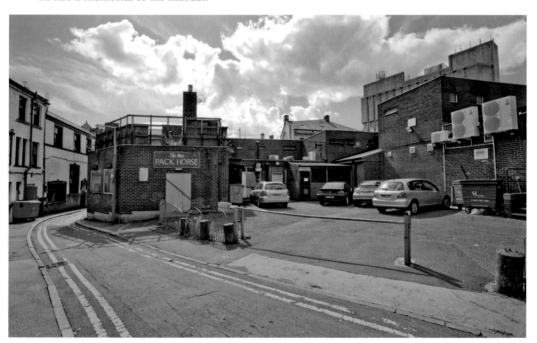

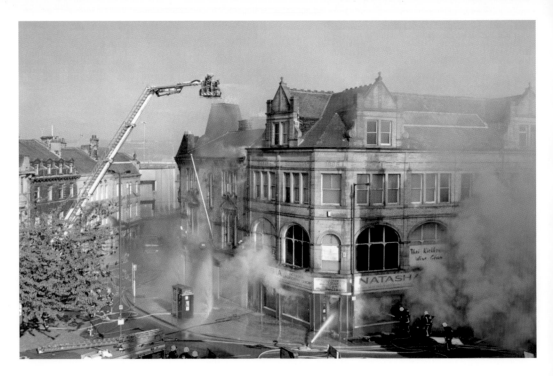

Barry's Buildings, 2010

Dozens of firefighters tackled the blaze to save Natasha's school uniform shop in upper Westgate after fire broke out on 27 May 2010. The shop was situated in Barry's buildings, built 1895. It suffered tremendous damage and to this day awaits either repair or demolition. One hopes repair is the order of the day, saving this little corner of Victorian Bradford.

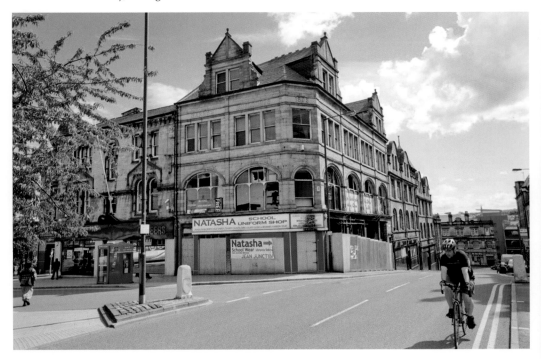

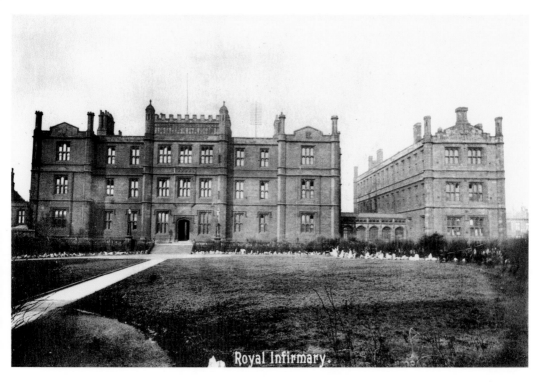

Royal Infirmary.

Bradford Infirmary, c. 1906

Nothing remains today of the former Bradford Infirmary, opened in June 1844. The hospital was situated on Westgate at the junction with Lumb Lane. Despite the title of 'Bradford Royal Infirmary', population growth made it overcrowded and it was eventually relocated to Duckworth Lane in 1937. Today the site serves as a pleasant recreational area in the shadow of the now closed Drummonds' Mill.

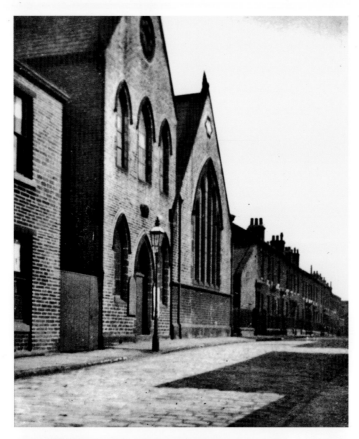

Zoar Particular Baptist Chapel, Darfield Street, *c.* 1906

Situated across the road from the Infirmary, the Baptist Chapel is where my great-great-great-grandfather, John Booth (a native of Thurlstone), began his thirty years as Pastor on 1 January 1898. In 1928 he was run over by a horse and cart in Peterborough and, although drowsy, managed to make the journey back to Bradford where he died in the Infirmary on 22 February, after undergoing an operation the previous night. Today the chapel, stripped of its pews, houses a food preparation company.

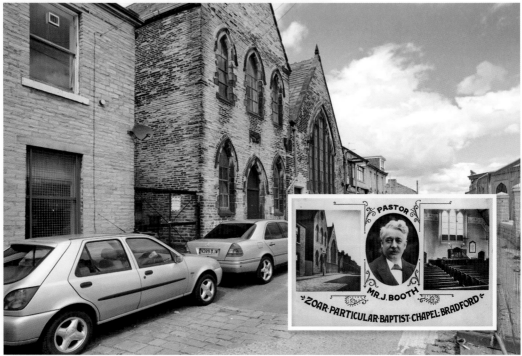

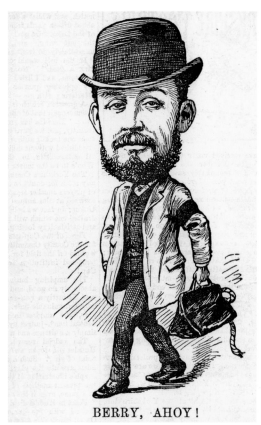

BERRY, AHOY!

1 Bilton Place, City Road, *c.* 1884
James Berry, Britain's official executioner from 1884 to 1892, lived at 1 Bilton Place. He didn't hide his occupation and would hand out a business card with his address printed at the bottom. Berry executed more than 130 people in his career before hanging up his rope. Today the site of his former home, described at the time as a modest slate-roofed villa, serves as a doctor's car park.

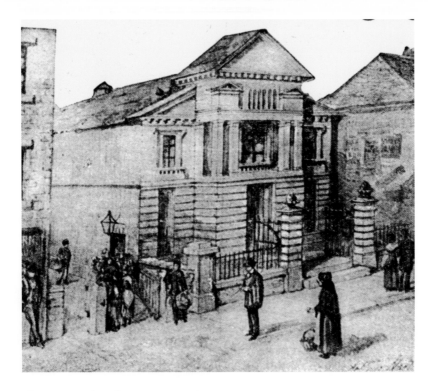

Theatre Royal, Duke Street, *c.* **1865**

Going back into the centre we find ourselves at Duke Street, the site of the original Theatre Royal. All that remains of the old theatre, which opened in 1841, is a weathered plaque on the wall. Originally the theatre was made of wood, until it was taken over by Charles Rice who designed a new frontage in 1844. The theatre closed in 1867 and Rice took the name to a new Theatre Royal on Manningham Lane.

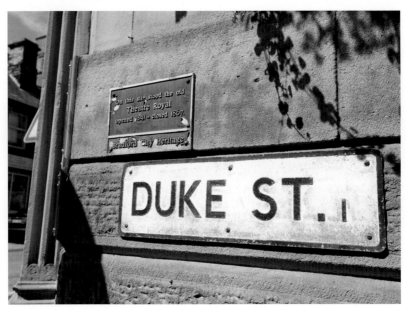

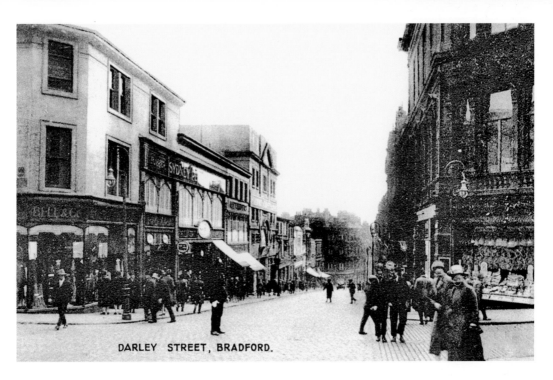

DARLEY STREET, BRADFORD.

Darley Street from Duke Street, *c.* 1927

To the top left is Bell & Co., blouse specialists. Lower down is the retail emporium of Sydney Pearson, costumiers. Looking to the right, the old Kirkgate market stretches into the distance. Examining at the same scene today, the new market is occupied on the corner by Boots whilst both Specsavers and Price-Less occupy Sydney's old empire.

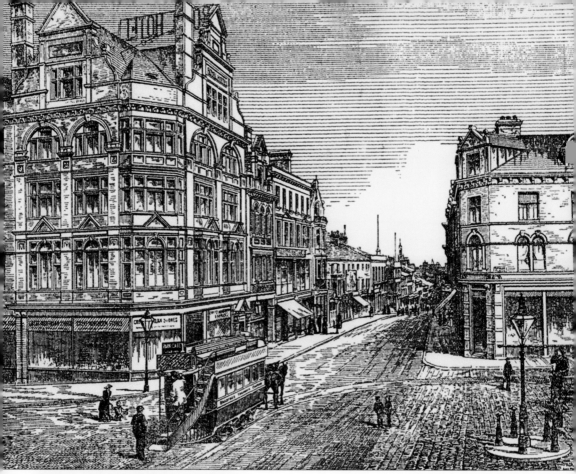

Royal Hotel, Darley Street, c. 1888
The old wood "shanty" along with the wilderness of waste ground had been swept away; in 1881 improvements to the top of Darley Street presented Bradford with an elegant head to the fashionable shopping area of the town. On the left-hand corner the new Royal Hotel can be seen. Built in the Queen Anne style, the hotel occupies the first floor and above. The lower floor accommodates 'Great Northern Stores'.

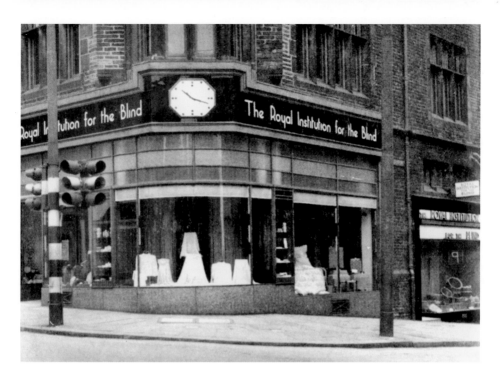

The Blind Institute, North Parade, *c.* **1957**

Turning around, we face North Parade. In 1957 The Royal Institution for the Blind displays goods made by the blind population of Bradford. Local work for the blind began in Bradford a hundred years earlier, when a Mrs Ray, the wife of a Wesleyan minister, sought out Bradford's blind and brought them together for weekly meetings. By 1866 the building we see here had been leased, the women were employed in knitting and the men in making brushes and mats.

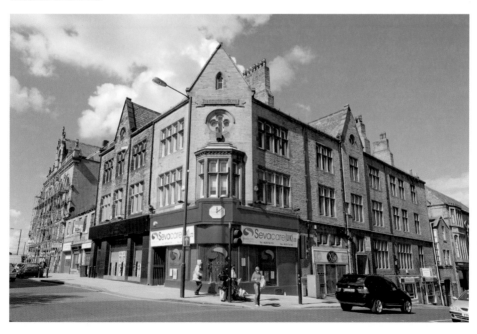

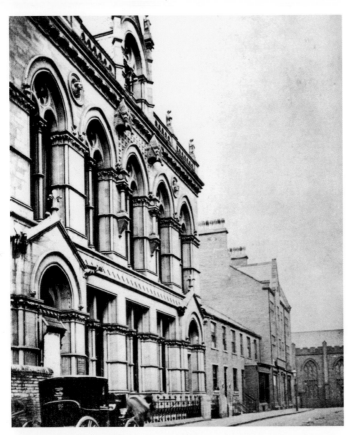

Church Institute, North Parade, *c.* **1875**
A four-wheeler cab waits by the newly built Church Institute in an otherwise deserted North Parade. At the end of the street we see Christ Church, just four years from being demolished to create a new route out of Bradford via Darley Street (as seen in the Royal Hotel image). Today the Institute is wrapped in scaffolding as it undergoes restoration work.

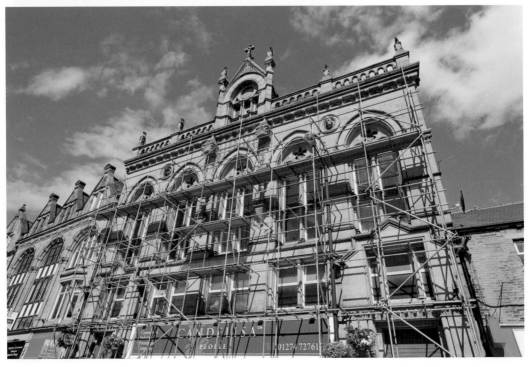

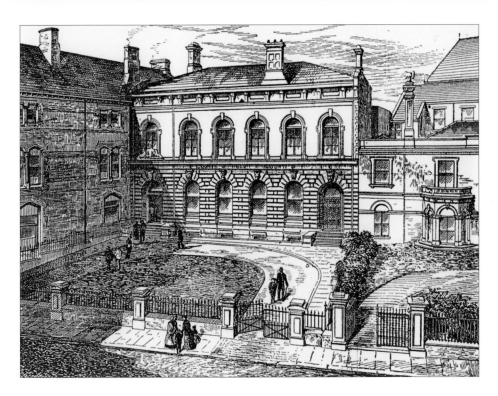

County Court, Manor Row, *c.* 1887

The County Court was built in 1859 during the regime of Judge Lonsdale, at whose desire it was erected in the style of Marylebone Court in London. Although the judge considered it a model of comfort and convenience the reality was somewhat different. The court, though spacious enough, suffered from an incurable acoustic defect. There was also a light problem that caused a strange shadow to be cast across witnesses' faces. Today the old court has received a sympathetic conversion into city apartments.

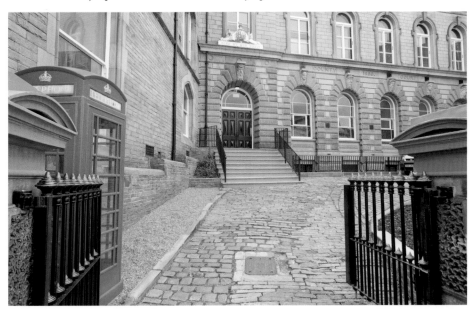

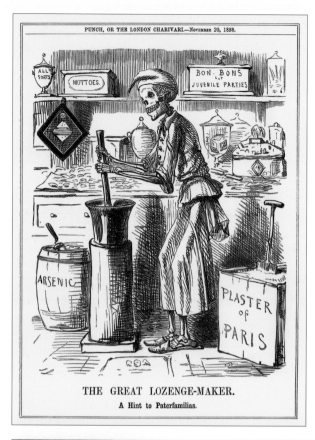

ALL SORTS

MOTTOES.

BON-BONS for JUVENILE PARTIES

ARSENIC

PLASTER of PARIS

THE GREAT LOZENGE-MAKER.

A Hint to Paterfamilias.

Stone Street, Manor Row, *c.* 1858
It is hard to believe that in this innocent-looking street off Manor Row would be the setting for the poisoning of more than 200 people back in 1858, of which 20 died. Joseph Neal (confectioner), who was in business in the city, was instructed by William Hardaker (known locally as "Humbug Billy") to make him a quantity of lozenges. Unfortunately, arsenic was used in the process instead of 'daft', a substance used to adulterate food. The satirical humour magazine *Punch* published this illustration at the time.

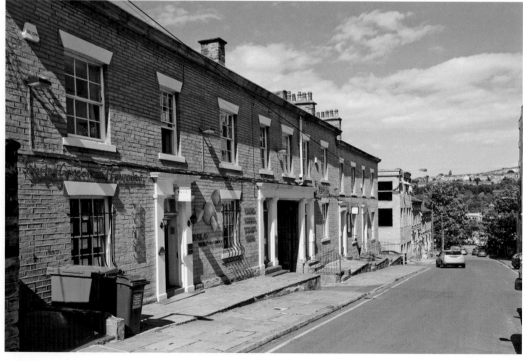

78

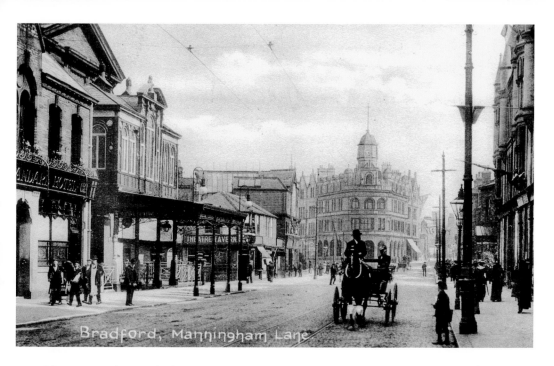

Theatre Royal, Manningham, *c.* 1905

On the extreme left is the Royal Standard Hotel. Between the Royal Standard and the Theatre Tavern is the Theatre Royal, where Henry Irving played his final role in October 1905. To the right, an open cab makes its leisurely way towards Lister Park. In the middle distance is the Yorkshire Penny Bank. Viewing the same scene today, all that remains is the Penny Bank building, converted into a pub that is now closed

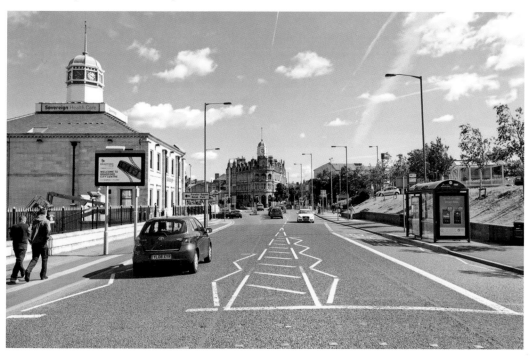

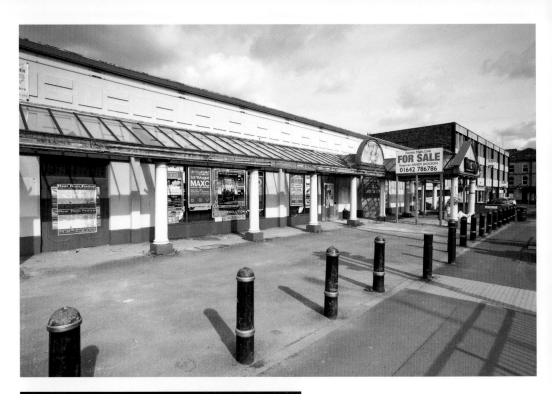

Pennington's, Manningham Lane, c. 2002

In 1960 the Mecca Locarno Ballroom was erected on the site of a former roller skating rink. Over the years this huge ballroom has changed hands many times. As a teenager I knew it as Dollars and Dimes; my mother knew it as The Cat's Whiskers. In more modern times it became Pennington's and finally the Town and Country Club, before its eventual closure. At the time of writing (2011) it stands empty, looking a little sorry for itself.

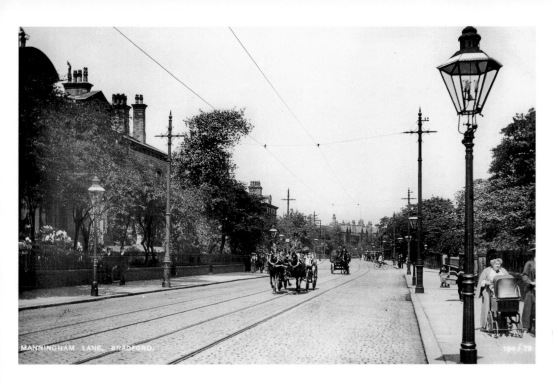

Manningham Lane, *c.* 1906

Moving in the direction of Lister Park we find a very pleasing scene. Large villas built for the wealthy line the road. St Paul's Road is ahead, to the left. In late Victorian Bradford this was the most desirable area to live in. A smart carriage heads towards us, followed by a delivery man. To the right, nannies wheel their charges in the direction of Bradford centre.

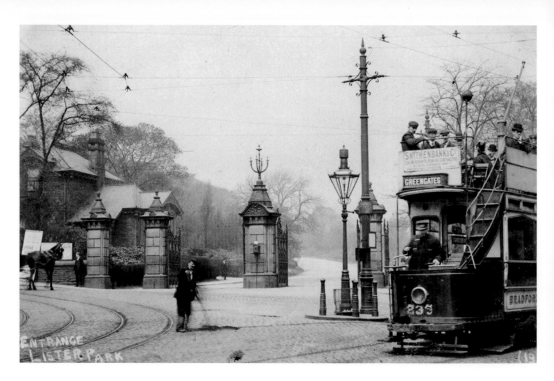

Lister Park Gates, *c.* 1905

As we arrive at Lister Park, then Manningham Park, gates, tram 233 passes us on its way to Greengates. The upper deck has two seats remaining if we are quick. A gentleman in a bowler hat looks thoughtful as he chews his fingers, while down on the ground a street sweeper goes about his work. In the distance the park's trees are losing their leaves giving us an indication that this is an autumn scene.

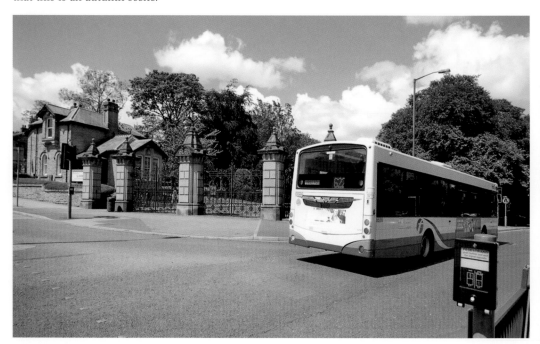

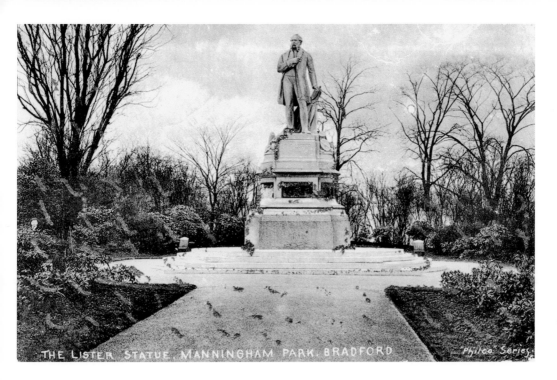

THE LISTER STATUE, MANNINGHAM PARK, BRADFORD

Philco Series

Lister's Monument, Lister Park, *c.* 1905

In 1870 Samuel Cunliffe Lister sold his Manningham Hall and Estate to the Corporation for £40,000, less than half of its market value. Thus the public acquired a beautiful park, which was then renamed in his honour. His statue – unveiled in the park on 15 May 1875 in a ceremony at which he was present – was carved from a block of white Sicilian marble. Lister is depicted standing with a two-foot ruler clasped across his chest. And there he remains, in all climates, watching over his former home.

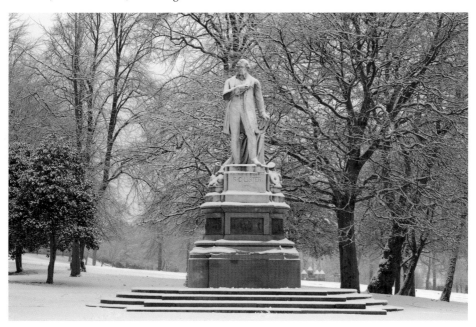

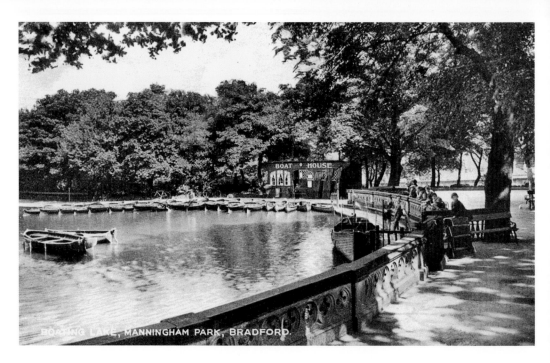

BOATING LAKE, MANNINGHAM PARK, BRADFORD.

Lister Park Lake, *c.* **1906**
In May 1904 Bradford turned out to welcome back the Prince of Wales when he came to Lister Park to open the Bradford Exhibition. At the time the lake was used to stage battles using scaled-down models of warships. Today the lake looks as peaceful and tranquil as it did in the photograph taken more than a century ago.

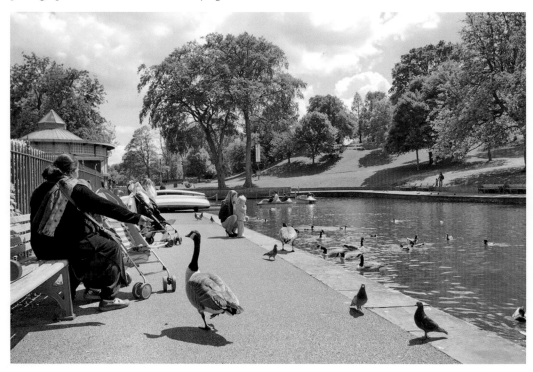

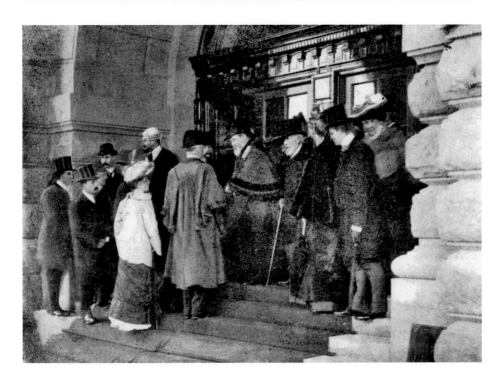

Cartwright Hall: Where is the Key? 13 April 1904

The opening of Cartwright Hall (as opposed to the opening of the Exhibition) was performed by Samuel Cunliffe Lister (Lord Masham) himself. He travelled from Bradford with the mayor and Corporation officials. The party paused *en route* to see Lister's statue decorated for the occasion, before making its way to the hall. Upon arrival, disaster struck: the gold key made especially for the occasion had been forgotten. A lesser replacement was found, however, and the formal ceremony proceeded.

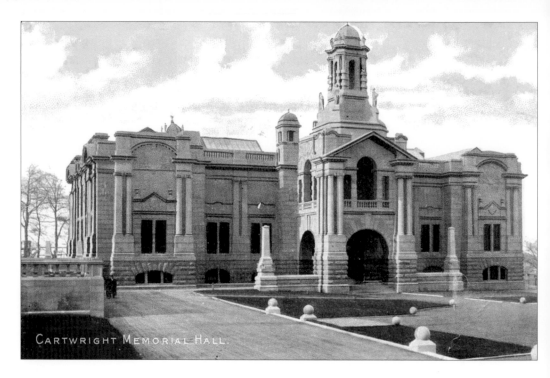

CARTWRIGHT MEMORIAL HALL.

Cartwright Hall, *c.* 1904
The hall, designed by J. W. Simpson in a flamboyant baroque style, was named in the memory of Dr. Edmund Cartwright who had invented the power loom. It was built on the site of Lister's old mansion following a substantial donation from Lister himself. Today the hall houses a permanent collection of nineteenth- and twentieth-century British art.

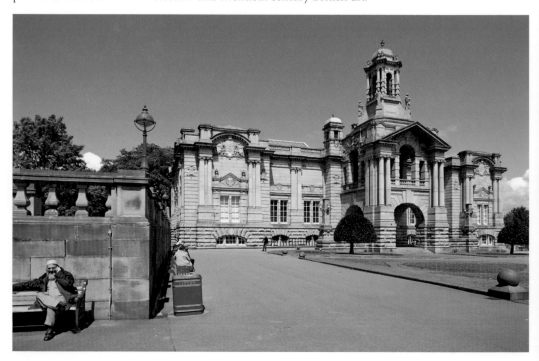

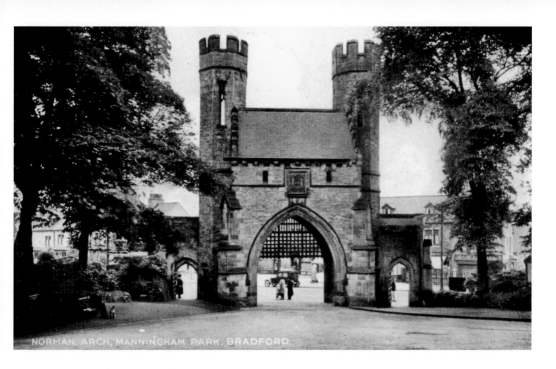

Norman Arch, Lister Park, *c.* 1903

This unique Grade II listed gateway was erected to commemorate the visit of the Prince and Princess of Wales (later King Edward VII and Queen Alexandra) in 1882. The gate, more commonly known as the Norman Arch, was built in part using stonework from Christ Church (on Darley Street, demolished 1879) which possibly explains some of its Gothic detailing. Not a lot has changed here over the years, apart from the modes of transport seen travelling by.

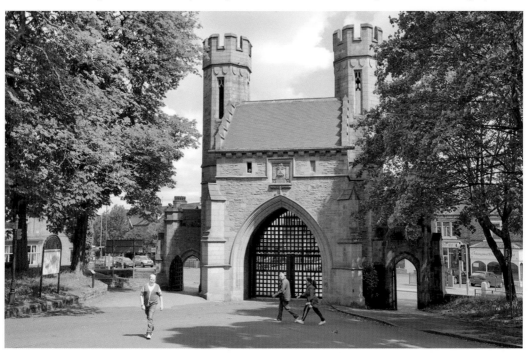

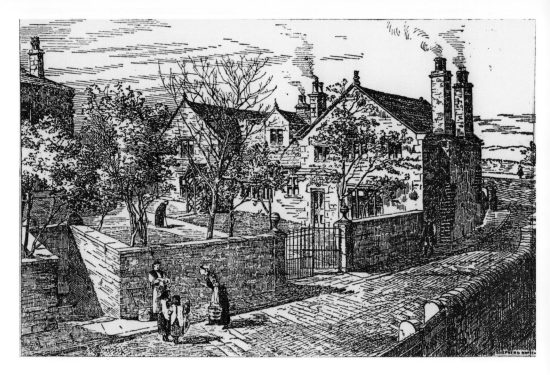

Manningham Manor House, *c.* 1889

The earliest known occupant of the old manor house, situated on Rosebery Road, was a fellow named Smith who sold it to William, of the Bolling family, in 1726. The family occupied the house until around 1780. Described as not very lofty but solid and substantial, the building was reduced and remodelled, the oldest portion of this ancient structure destroyed, as part of street improvements in the 1890s. Today it lies derelict awaiting restoration.

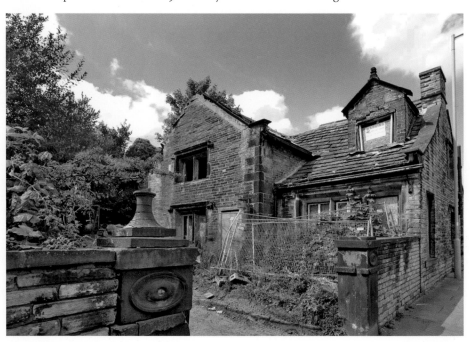

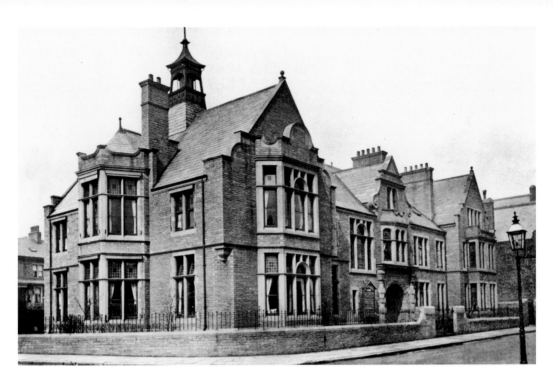

St Catherine's Home for the Incurables, *c.* 1900

The home for cancer and incurables was opened on 1 October 1898 by Lady Frederick Cavendish. Accommodating twenty-five patients, it was the only home of its kind in Yorkshire. It was built at the sole expense of Mr and Mrs Cawthra in a modified Queen Anne style and inscribed over the front door was the legend 'To the glory of God and in the memory of their son John Wm Briggs'. This once-proud building is now derelict and awaiting a buyer.

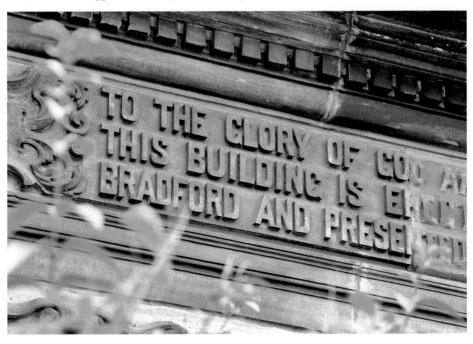

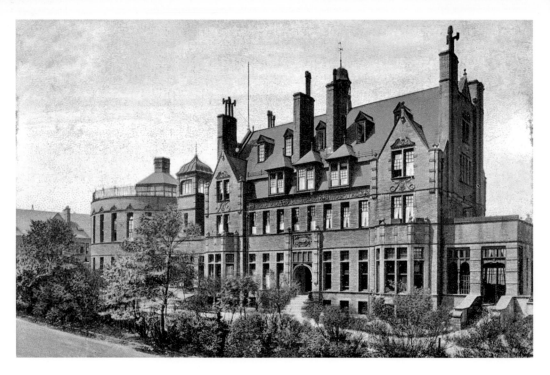

Bradford Children's Hospital, Manningham, *c.* 1904

On 1 May 1889, in pouring rain, Samuel Cunliffe Lister laid the foundation stone to what was to become the new Children's Hospital. He donated £5,000 and was invited back to the opening ceremony in October the following year. It was the third move for the children's hospital in six years. When eventually the hospital closed it became Nightingale's Nursing Home, which closed in 2006. Today it serves the Muslim community as a mosque.

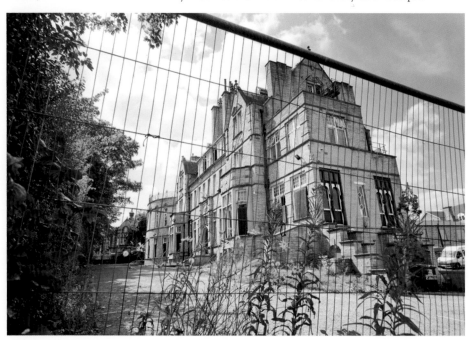

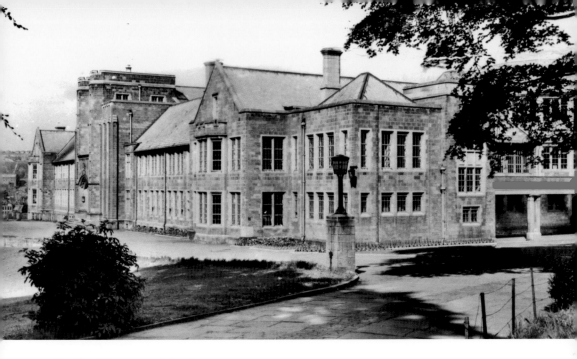

Bradford Grammar School, *c.* 1950

One of the oldest and most respected institutions in Bradford, early records place the school close to the parish church, being already well established in the mid-sixteenthth century. Today the school finds its home at Frizinghall. Although completed in 1939, the building was used as a primary training centre during the war and it wasn't until 1949 that the school moved from the inner city to its present site.

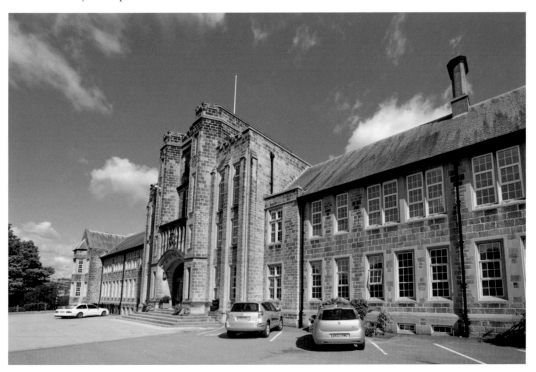

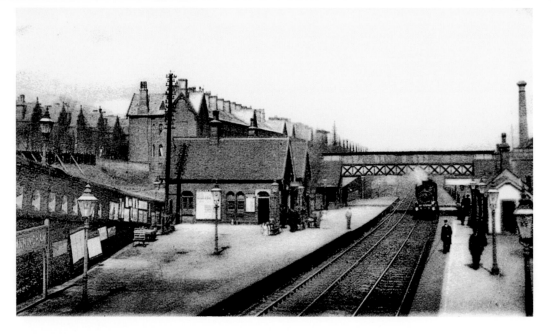

Manningham Railway Station, c. 1903

Situated just off Queen's Road, Manningham, the station opened in February 1868. It was the first stop out of Bradford on the old Midland line. A scene to please any steam enthusiast, it was to close in 1965, along with Frizinghall (which re-opened twenty-two years later). Looking at the same location today it would be hard to imagine the station ever existed in what is now a yard for a demolition company.

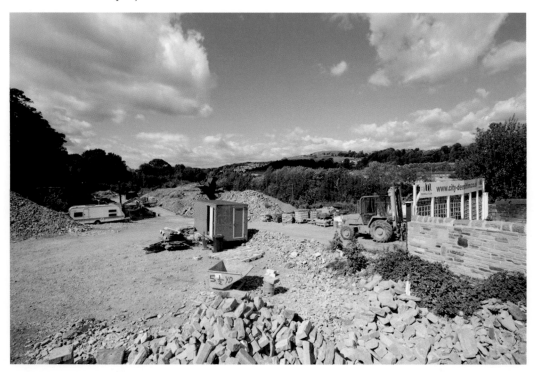

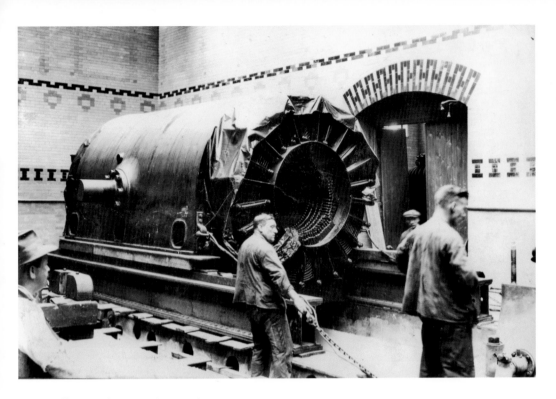

Valley Road Generating Station, c. 1930

The recently commissioned Princess Mary Turbo Generator is seen being installed at Valley Road. By the mid-1930s it was the most powerful generating station under local authority control. The generator was powered up by HRH Princess Mary herself in 1930.

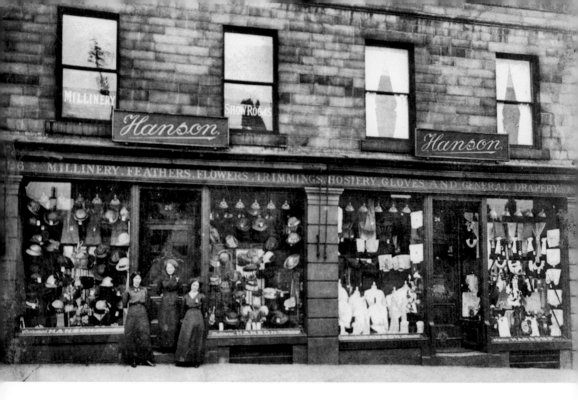

24–26 Carlisle Road, 1913

Although it is now 1913, the Edwardian influence can still be seen in the window displays at Amos Hanson's millinery showroom on Carlisle Road. Shop assistants stand either side of their manager for this posed photograph, giving us a glimpse of pre-First World War Bradford. Nearly a hundred years on, the sign board has slipped a little, but RANI Boutique is still retailing clothing and accessories in the two linked shops.

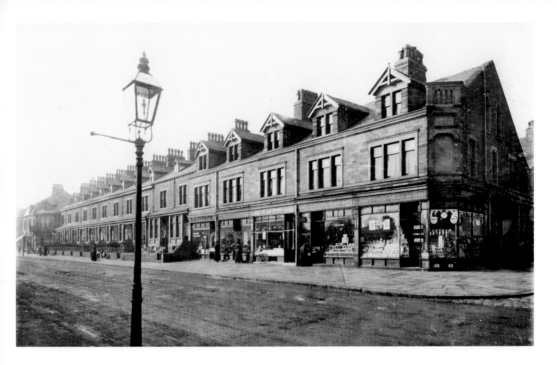

Nearcliffe, Lillicroft Road, *c.* 1910

Edwardian shopping in the suburbs; from left to right: Harold Precious, dyer and cleaner; Miss Maud Northrop, milliner; William Sherwin, butcher; Cristian Vincent, fruiterer and finally on the corner Arthur Walker, grocer. True to tradition, the Nearcliffe buildings still provide locals with their provisions.

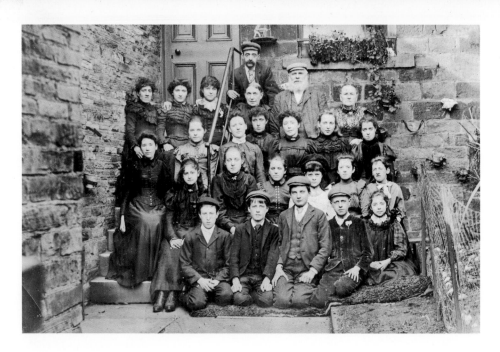

Factory Workers, *c.* 1900

And here we end our journey in the place where many of the people instrumental in the growth of our city ended theirs. Be it the lowly mill worker or the great industrialist, Undercliffe Cemetery was to be their journey's end. Be proud of this cemetery that overlooks our city, for it represents everything that was our Victorian Bradford. As local historian Alfred Robinson said of Undercliffe, 'This is indeed Bradford's history in stone.'

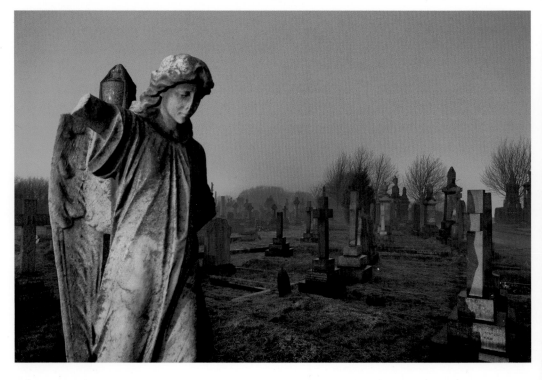